Art and
Human
Emotions

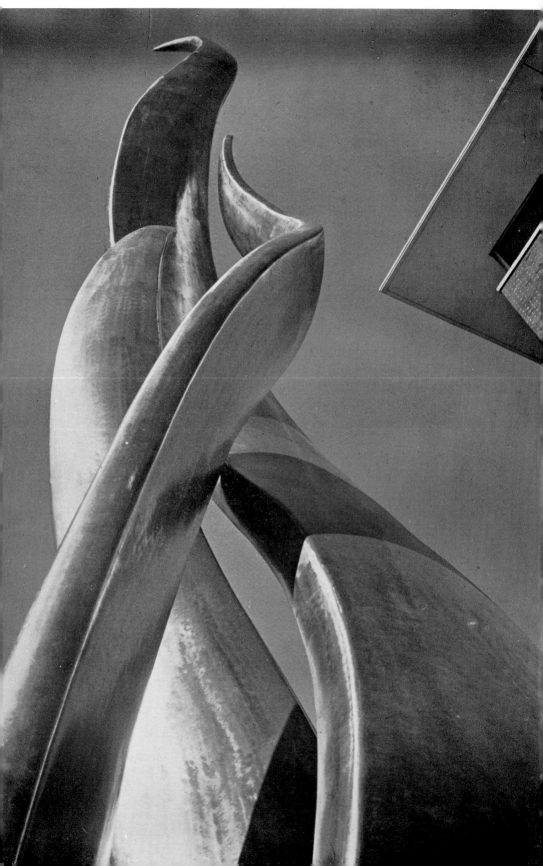

Art AND Human Emotions

By

EGON WEINER

*Sculptor
and
Professor Emeritus
Art Institute of Chicago*

CHARLES C THOMAS · PUBLISHER

Springfield · Illinois · U.S.A.

Published and Distributed Throughout the World by
CHARLES C THOMAS • PUBLISHER
Bannerstone House
301-327 East Lawrence Avenue, Springfield, Illinois, U.S.A.

*With THOMAS BOOKS careful attention is given to all details of
manufacturing and design. It is the Publisher's desire to present books that
are satisfactory as to their physical qualities and artistic possibilities and
appropriate for their particular use. THOMAS BOOKS will be true to those
laws of quality that assure a good name and good will.*

Printed in the United States of America
C-1

Library of Congress Cataloging in Publication Data

Weiner, Egon.
 Art and human emotions.

 1. Art—Psychology. I. Title. [DNLM: 1. Art.
2. Creativeness. 3. Emotions. BF408 W423a]
N71.W425 701'.15 74-16414
ISBN 0-398-03265-3

TO MY MOTHER*

When in springtime
The flowers grow again
After a lonesome, dreary winter,
We are all happy,
And I am even happier
Because I know
My Mother loved flowers so much.
They grow and bloom
And when I look at them
Face to face–a whispering question–
"How are you, my son?"
And I answer with tears in my eyes
And an inexpressible feeling,
"I am fine, dear Mother."
Whenever I see flowers
I meet my Mother again.

*(She died in Europe during the war. We do not know how, when or where.)

Foreword

Webster's Dictionary, among other definitions, characterizes art as "skill . . . derived from knowledge and experience" –a seemingly simple equation, yet one that contains profound philologic and semantic wisdom. *Knowledge,* in the classically comprehensive sense of Greek *gnosis,* implies not merely in-formation–the influx of stereotyped *forms*–but an *e-motional* (inwardly moving) perception of their subjective meanings and poetic interrelationships. In artistic creation, this empathetic *ex-perience* (which pierces through) then transcends mere sensations to inspire a special *skill* that distinguishes the *artist* from a mere *artesan.* Praxiteles, by tradition, did not chisel marble: He immortalized as gods the inner as well as outer beauty of athletes and philosophers. Michelangelo painted a physically potent but existentially troubled Adam reaching toward a beneficent God and obviously created in his own image. Mozart, with quill pen on reused copy paper, created eternal rhapsodies to human loves, joys, sorrows, and aspirations, to which Beethoven added the counterpoint of man's challenge to the Fates themselves. As Egon Weiner notes, "Picasso says we are ugly, and we hate the guy for it, but he says the truth," thus bringing to light another facet of the human condition from which true artists (and modern composers) do not avert their eyes.

Which brings us to this book on art and human emotion. In it, my friend Egon Weiner, in his flowing, free-association style, is as facile with words as with his musically attuned senses and his creative hands. Let us consider some of his verbal sculptures, here previewed with a minimum of paraphrase:

"We are all artists: The child cries (after a resounding

sensory guteal experience rather than cold reason), and music
is born. . . . Does the position of the bare canvas on easel,
wall or floor matter? Which position creates a child best?
. . . Weavers, if artists, should know astronomy. . . . Men
need to create; women *are* creative. . . . An artist can be-
come drunk (ecstatic) with emotion. . . . If no two snow-
flakes are alike, can anyone 'copy' a work of art? . . . (As
through a stethoscope) every heart keeps repeating 'to do,
to do, to do.' . . . Masterpieces (of paintings) are drawn in
the air by conductors who make music. . . . The finest things
are those we do not see but just perceive. . . . I worked two
years on (a monumental sculpture), 'The Pillar of Fire,' and
when it was erected, I was still on fire with nothing to burn.
. . . Seurat forces our eyes to mix his (unnatural) dots of
color to produce a painting. . . . A pebble is sensuous be-
cause water caressed it for hundreds of thousands of years
and made it beautiful."

Art is "long" but, as part of a more mundane life, prefaces
should be short. One approaches a work of art first by savor-
ing a few unique details. They merge, re-emerge and then
merge again with the whole. This book is such a work of art,
and the reader is so invited.

<div style="text-align: right">

JULES H. MASSERMAN, M.D.
Professor Emeritus of
Psychiatry and Neurology
Northwestern University

</div>

Contents

This lecture was given on the occasion of the unveiling
of the statue "Christ the King." This lecture showed the
audience the scope of this work as well as variations of
approaches to similar projects.

This lecture was given to convey to craftsmen the idea that
their work can be art if creative abilities are involved.

This lecture was delivered at the 122nd annual meeting of
the American Psychiatric Association. The audience was
invited to art with a courageous and adventurous spirit,
discovering the subtle symbolism and analytic insight which
can be gained from it.

This lecture deals with creativity through autobiographical
comments and statements about other artists.

This lecture dealt with art education. The illustrations
exhibited the development of the monument "Pillar of
Fire," commemorating the victims of the Chicago fire.

Art and
Human
Emotions

Lecture to American Lutheran Church

OSLO, NORWAY, AUGUST 27, 1967

ADIES AND GENTLEMEN, this is a great day for all of us, and it probably means more to you than to me because it is, on the whole, your day. I am free; I don't carry the burden anymore; it's yours. I am already thinking of other things. As I told Reverend Nelson, the great experience missing in the life of a man is that he doesn't know how a woman feels. For instance, I think I feel right now the way a woman must feel when she has a baby and someone adopts it. She is hoping and caring, and then nothing is there. It is always the other side we are interested in. Females are the salt of the earth. From birth by women we start. Women are usually behind the man, as in the anatomy of man where the backbone is behind us and is also the strongest support. So it is in life and in art. There is always a woman behind us–and don't ask who. She keeps us going, she makes us hopeful, she makes us creative.

Sometimes I think artistic desires and the deep yearning of the artist are a sort of frustrated motherhood. The artist wants to give birth to his own thoughts, his own feelings, his own desires because fatherhood is just a played-up role to

3

give men something to hold onto. Fathers function for a short time and then are not necessary. Therefore men must do other things besides fathering children. The deep expression a man wants to give to his thoughts and feelings is not so easy to get out. What he gets out is only part of what he feels. That part should be enough, but sometimes it isn't–most of the time it isn't, but that's all he can get.

When you look at a statue, a figure–I am speaking particularly of this Christ figure–it is not just a man with a beard. There are many men with beards who are not Christ. It was a fashion of the time. In art, we usually get cheap images of Christ that sell in the millions. These images hang in the rooms of pastors who get them from the women's clubs. Every Christmas, the woman's club gives the pastor a picture of Christ, and he has to hang it up, naturally. There hangs that smiling, handsome, beautiful, pretty Christ. And it is so far from what it really should be. We see the beauty, the superficial illustration of our wishful thinking. Christ couldn't have been handsome, he couldn't have looked so good. He approached the poor, the sick, the unhappy, the disturbed ones. If he had looked so handsome, so different from them, they would have been afraid of him. He must have penetrated the inside of man to catch his soul, and one can't do that by being handsome or pretty. Soft talk or sweet talk won't do it either, even if that's what we want to hear.

The same is true of the artist's work. He makes a figure. Naturally, he knows how to do it. The knowing how is the beginning. The knowing how is just the point of departure. But, for this, we artists are admired. That is the least we should be admired for. Naturally, we know how to make a statue, but the making is just the tool–what we feel, what we create is the surprise. The artist's mood, or love, go into the figure too, and then he abstracts from it. His own face, his own doings, go into a work, and sometimes it looks strange to him. He wonders, is it I or is it some influence? And, especially when it is of the self, it looks most strange,

because we don't know ourselves and most of the time we don't like what we see inside. It is as simple as that–when we don't feel good and we look in the mirror, we don't like our faces either. We try to change them, sometimes successfully and sometimes not, but it is rather like a camouflage.

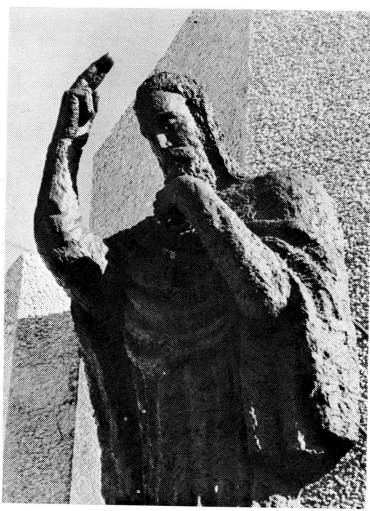

Figure 1. "Christ" on the American Lutheran Church in Oslo, by Egon Weiner. Bronze, 1965.

One can cover one's face, but one cannot cover one's inner feelings or soul. It is better to show them than to hide them, and the happy artist is one who gets out his feelings and emotions.

I teach drawing and sculpture, and when I walk around and stop, the students are a little disturbed. It is like the piano teacher coming and looking over your shoulder–then you play a few sour notes. So I look, and he or she looks up and says, "Well, this is not a good drawing; it is horrible," before I say a word. And I look at it–I must say I cannot lie to a student. So I say, "It is bad; it is not so good." Then I say, "Who do you think made it?" Well, there's a sort of surprise in the face of the student, and he says, "I did." I say, "You know what? You should be very happy about it. You saved yourself a nightmare. Be glad you got it out of your system."

I am known at the Art Institute as the teacher who says, "Make another one." If the work isn't good, I say, "Make another one." Don't work too long on one thing. This is something everyone probably does in his own life many times. Let's say I wrote to a very important person and I signed the letter. Then I looked at this, my own signature, and for that very occasion it didn't look good enough to me. So I went over it again and made better letters, finer, more regular letters, as a signature should look; and it did look better. We have all done this, I am sure. But one thing we can't hide is that although the name looks better, it has lost its character. It has lost the truth that I was nervous when I signed the letter this way. That's how the signature should stay, but we want to brush it up and have it look better because this is important to us. It looks better, but it is meaningless and without emotional indications.

You Norwegians had a very great artist, the genius of Scandinavia. You had Edward Munch, and every time I come here, I go to the Munch museum many, many times.

I hear people say of Munch's work, "It isn't finished; this is a sloppy job; the color is running down there." And I will say, "You know he was so full of enthusiasm, he couldn't stop to fix that. If he had fixed the running down of the color, he would have lost his inner fire–his inspiration. A painting isn't a room to be kept in order. It is an emotional outburst, and you can see it especially in Munch. The suffering of his whole life bursts out. When he was five years old, he saw his mother die, and when he was twelve years old, he saw his sister die–both of tuberculosis. His other sister went insane several years later. He painted it all. Now, tell me, when you are touched by such inner emotions and chaos, how can you think about whether the color is running down or not?" Then they say to me, "I know a better painter; he paints so nice and clean, so accurately," and I say, "This artist paints without emotion." We want the emotions in art, the expression of that fire that burns in all of us, and the artist has to show emotions in his art, because others don't. You could do it maybe, but maybe you are afraid. Maybe you want to impress instead of express, maybe you don't want to take the risk of being exposed. We artists take the risk. If you know art, you can read artists inside and outside. We expose ourselves, and most people don't want to expose themselves. If art isn't an exposure of thoughts, feelings, and emotions, it is meaningless.

What do you think an artist does after the statue is unveiled? That is a question I was asked just before I came in, and I said I would answer it in the lecture. So what do you think an artist does? Usually, people think I lie down and sleep. I might have a good drink. Some do; I don't condemn it, but I did not. I was brought to my room, and I changed out of that rather fancy, disagreeable suit I had on. First, I ate sardines and eggs. Then I took a short walk into the forest and swam. I cooled off for sure. The water was pretty cold, but very healthy, so I think I am back to normal again. I hope so.

As I have said quite often, by birth, environment, and education I am an Austrian–to be precise, Viennese, because my background goes all the way back to Vienna. By citizenship and further artistic development I am an American. In the United States, I developed a quite modern and abstract style. I am often asked, since my other works are so abstract, how I came to make Christ so realistic, because he looks like a human being. People ask, "Why don't you abstract him?" Or my artist friends who are abstractionists say, "Aren't you going back again to the things you did before?"

If they hadn't asked, I would not have thought so much about it. But once an avalanche is loose, it starts to roll. Thinking is the same way. Once one tips it off, it starts to roll. So I thought about it, and I came to the conclusion or conviction that religious figures, especially the image of Christ, can only be realistic because *the Word became flesh.* The meaning became a human being. He went through natural birth like any other human being. Now, how could I abstract that? The meaning would get lost. The only thing that could be abstracted would be Christ before his birth or after his ascension. I think that this statue may be my last realistic Christ. Since it is my best, it should be my last. But could he have looked before his birth as he does in the pictures we see of him as he was on earth? I will have to think about that.

Every work, if it is creative and great art, is abstract. The same is true of human beings. We look at one another and we expect to see faces. The faces vary. They are different faces according to the parents from whom they come. But we forget that there is an inside of us that doesn't look so agreeable, and it is very abstract. The most abstract thing–the soul–is within us too. So don't fight it. If you believe just in the surface, then you can say, "I want to see a face with a smile and pretty eyes and a cute nose," and that's a cheap desire. People make the mistake of thinking that their wishful thinking in life should be represented in art. When they see Marilyn Monroe, they want art to look like Marilyn Monroe,

but when we show them a rather ugly, distorted face, they say, "We don't like it." And I say, "You don't have to marry her. This is a picture. You make your own picture. It is an expression." I want to make visual what we are talking about.

At the McCormick Seminary in Chicago I spoke to the faculty about art and religion. They were all festive there, and their last year's students were also invited. I brought a work in iron, very rusty iron. I liked it. I asked the audience, "Now what do you think about it?" I wanted to establish that this was a piece of modern art, cut out of rusty iron with a torch, and I had left it rusty. I called it "Jacob's Ladder," but my audience didn't know that and I didn't want them to know. So I said, "What do you think?" The dean said something about heaven, and a lift up. And someone else said, "a stepladder," which was pretty good. There were some good answers, close philosophically. I wanted them to have the courage to give answers, and I encouraged them. One young man, a third-year theological student, said, "May I tell you the truth, Mr. Weiner?"

"Well, sure, I try to tell you the truth."

He said, "It means nothing, really nothing. This is nothing."

That I had had such a good dinner before the lecture had something to do with my reaction, because usually if I get such a reaction I might get a little sore. But I was so cheerful and so satisfied. I was untouched by good or evil. So I looked at him, and I got the idea that I have used since in lectures. I am grateful to that young man, because I said: "You know what, you are far ahead of me because I do not know how nothing looks. *I never would have come to that. You see, nothing does not exist. What is nothing?*" And I must repeat, I am grateful; I never would have said it so clearly because there was no chance or need to say it before.

I could tell many stories about the commissioning of art, but this is an especially good one. I worked with a church

committee of very decent people, having a taste for cheap il-
lustrations and cheap religious art. They felt that things
should look like the art they knew. The poor minister, who
had studied his whole life, had never had a course in art or
architecture. Ministers are trained, fine people, but when it
comes to building a church, they say, "I saw a beautiful
church in Paris and I shall build another like that." To come
back to that committee, every day I heard from the minister
what he would like to have. We talked and talked, and finally
the committee decided to spend the money. Then they said,
"Show us a sketch," and I declined. I told them, "If I make
a sketch and don't stick to it, you'll say I broke the contract.
Ideas are like life. A small idea is small, even if you make it
large. A monumental idea is monumental, even if you make
it small. Now, a baby mouse is small and a baby elephant is
large to begin with. Even if we were to make a mouse large–
enlarge it enormously–it would still be a baby mouse. And
if we took an elephant and made it small, it would still be a
big animal. You would say, 'I don't want that big elephant;
show me a small one first.' It can't be done. Great ideas are
great, powerful ideas are powerful, and small ideas are not
weak, they are just small in size. So how can we show them?
So," I said to the committee, "no model."

"How will it look?"

"I don't know."

"Listen, we are spending time and money, our money,"
and so on.

And I said, "Look, why did you call me?"

"Well, we heard you were a good artist."

"Fine. If I am a good artist, you will have to trust me." So
we went on for hours.

I had to go out of the state, and it looked as if I would
lose the commission. They kept saying, "We want to know
what we're getting," and "What shall we do?" and so on.
Finally I got an idea. It came at the final meeting, and it was
really the last chance I had. I said to the committee, "I want

to make a point. You are fine people and you are spending your money, and I appreciate it very much, especially since you want to embellish the house of God. I realize that if I fail you, you lose that money. But I will show you the other side of it. If I fail you, I am an artist failing in the making of a work of art. I lose my reputation, and in this special case I fail in making the image of Christ! Now who do you think is losing more? This is what an artist really is. You can't worry about losing the money. Money isn't so much. It is difficult to get, but, as we say in the church, 'Man does not live by bread alone.' And that's the way an artist is. You'll find in history that some artists really starved, whoever they were, unless they were understood."

Now, artists have to fail somewhere, and that is what the public, who commissions us, is afraid of. People say to us, "You are a good artist, but we want to be sure, so the committee will tell you what to do." And they look around and they say, "Why has my grandmother dark hair? We Swedes are all blond." We hear that everywhere. We artists are surprised with the outcome of our works of art, and sometimes even frightened when we see what we were doing or did do. There is a meaning.

We sometimes think of an artist as an acrobat. Well, he should be clever with his fingers, naturally. But he is sometimes like a poodle in the circus. The poodle stands on his hind legs, goes around and looks intelligently at someone, picks up the stick, gives it to the master, and plays with the ring. He is so human and so admirable that we all give him a great hand. But we miss one thing–well, actually the poodle misses one thing–he loses his identity as a poodle. It is the same with us when we get so superficially acrobatic in proving what we can do!

I think we were talking about how artistic people are. Students come to the Art Institute, to my class, and say, "Mr. Weiner, I can't draw a straight line." (At the institute, we have models for life drawing, sculpture and painting, meaning

nude models.) I say, "Yes, but what difference does it make that you can't draw a straight line? I would like you to show me a straight line on this model." There is no straight line on the whole human body, not even the bones. The bones have "S" forms. Otherwise we couldn't walk. And the collar bone, as you can see, is the most outspoken "S," by all means. So what do we need a straight line for? The straight line is an invention of mankind. If I need one, I can take a ruler and make a straight line. If you look at the walls of your church, as I have done lately, you will probably see that they are not straight, even though they were drawn on the paper in straight lines like this. But the direction of them is straight. Look at a rock. You never find a straight-lined rock. It is from our human insecurity that we seek to be straight, to be perfect, which we aren't. That's why we modern artists like the dripping colors, the uneven distorted forms, which are more human, more like us. Even if you are nervous, and your hands are shaking, you can draw. If you have a sense to draw, you can draw.

Now we come to the point: Everyone is an artist in some way. This was discovered hundreds of thousands of years ago. The mother takes a newborn baby and puts it in a crib or in the hay, and puts some little red, blue, or green objects in front of the baby. There is that baby looking at the objects. The baby's eyes cannot focus, but after a while, the baby becomes alert, looks at the object, and experiences the sensation of color: just the beginning of the painter. And then the child is not satisfied with just looking and reaches for the object. When the child touches the object, it experiences the sensation of touch and form, and that is the beginning of the sculptor. When the baby was born, the doctor turned it upside down and gave it a whack. It started to cry. That was the first tone on the first instrument, the human voice, and the beginning of the musician.

And I tell you there is not one of you here who didn't do that. You got the gift, but you left it where you got it. The artist goes on from there, and is driven by it. It is not a vir-

tue; it is a must. But the excuse that you were not exposed is not valid enough. Naturally, you go into other walks of life, and become interested in so many things. So, when it comes to the question of commissioning works of art, now that you are a very honored and powerful man, you go back to the first impression of your youth, to the picture you saw in Sunday School. Therefore, I tell every minister: Don't buy those cheap, devotional-store goods for your churches. Even if he has no money, he has enough people who will give him a supply of paper and some pencils. He can read the Bible to the children as well as he can, and they will draw their own God. It will certainly be better than we could do, and purer too!

Talk Before Weaver Group

ONTARIO, CANADA

HY ARE REMBRANDT AND PICASSO so good that we can't do what they did? Because we don't feel what they felt. That's why an artist can't copy. Copying is reproducing the surface, the skin, the superficiality. If I look at you and you look at me, we see each other now speaking about a subject we are both interested in. It is not just that I see your nose and your eyes and your lips, nor do you see only my nose, my eyes, and my lips. We vibrate to each other. And, as I always put it after a lecture that has gone well, you did it as well as I, because I need the warm wave of interest and concentration coming toward me, and I reflect it back to you. It is our common goal, and I don't know who started it. Maybe I had to start with the first few sentences, but from there on we are together. So, I couldn't speak it or write it without you. You speak to me in a very verbal silence. Now how would that be copied? Paul Klee–the father of modern art, contemporary art–put it wisely. "I want to paint the unseen, the unheard, the unknown, and I want to make it to be seen, heard, and known." So how can you correct him? How can he correct himself?

There is something beyond all of us, and someone has to

14

reach it; but if he does, we condemn him. We say the other artists didn't paint this way; this is no good. I had very good colleagues, many of whom you know. They were good painters and had established themselves as such. Then ten or fifteen years ago, along came Jackson Pollock, the action painter, with his drippings, and people said, "This is not painting; this is nothing!" Don't forget I am a sculptor, and sculptors are minor artists in the eyes of painters.

What does a sculptor say to his painter friends? I said, "You know, Jackson Pollock's paintings have good colors. There's an enormous rhythm in them."

"Oh, come on, don't tell me," they said. "He doesn't pick up the brush, he doesn't paint, he doesn't do anything on the canvas, and the canvas is not where it should be–on the easel."

I said, "In the last two or three hundred years when easel paintings were known, some paintings were good and some were not so good, whether they were done on the easel or not. There was an artist, and it didn't matter how he got a painting." I wanted to make my point clear to them, because they were very belligerent. They told me, "You don't know anything!"

I said, "You might be right, but how much do you know?" To me a great painter, an artist, has to be creative, and if the canvas is this way or that way, or if the paint is put on with a brush, orderly and academically, or splashed on the canvas, I do not care in which way or position it is applied. Number one is creation; a child is conceived! As long as it is conceived, I do not care which position the canvas, the color, or the artist is in when he creates. And we still don't know today which position is the most creative one to bring forth a child. So why pick and fiddle around, and say one has to paint this way or that way?

Art is life, and life can be art! When I was young, we were not taught how to kiss a woman, how to approach her, or how to get children, nor was she. But we did it, and the fu-

ture was resting on it. Our predecessors taught us how to do
everything except that. How did we know this? We didn't do
so badly by the next generation.

You can't teach another person anything. You can only
expose the person to the things he has within himself–this
was said by Galileo, the scientist. I think it is one of the
greatest teachings of art, or of any pursuit. I repeat, man can-
not teach another man anything. He can only expose another
to the things he has within himself. Now, as I start teaching
at the Art Institute, the students come in and they wait. "Tell
us what to do," they say. Now remember what I said earlier
about courtship. They told us, "Don't go out with the girls,"
and they always told the girls, "Don't go near the boys." But
we still did. And there the students sit in the class and ask
me what to do. So I say, "Draw, there's the model."

"Well, I don't know how."

"There's the model; there's the paper; draw."

"But it will be wrong."

"So it will be wrong. Besides, who decides what is wrong?
Maybe your wrong is right and your right is wrong. We'll
find out. Get lost; express yourself; and then we will talk
about it." You wouldn't go to a doctor with a boil under
your arm, a very ugly one, and say to the doctor, "That's a
beautiful arm." You have to express yourself, and your body
expresses yourself. Sometimes you feel ashamed, but in order
to be helped, you have to express yourself! And in art it is
the same. When the student shows me a bad drawing and
says, "Look, Mr. Weiner, it's a horrible drawing, isn't it?"
I look and I agreed. "It looks rather bad. Who did it?"

He says, "I did it."

I tell him, "Well, you know what? You saved yourself a
nightmare, you got it out of your system. Make another
one." There was deliberation in his drawing, you know. He
had to draw it out of himself. What's wrong with that? We
always want to show ourselves off. We're pretty, we're beau-
tiful, we're smart, we can draw well. The bad things we cov-

er, cover, cover, and some day they stink to heaven. But we'd better do something for or against it, at least let the air come to it.

When I tell a student to make another one, he often asks, "Well, shouldn't I correct it?"

I say, "No!"

"Wouldn't it be better?"

I say, "No! It would only look better in your eyes. You cover up. You erase the mistakes. Where did they go? You hide them. You camouflage the errors. And then a year later you say, 'I was doing quite well.' It is an illusion. I want those drawings. I need those mistakes and errors. I don't call them mistakes. I call it a condition–a condition to scribble. You are expressing yourself."

The artist is like a seismograph. The seismograph shows an earthquake in Tokyo, and we realists and materialists sit here and say, "There is no such thing, he's fooling us." Then, in our grandparents' time, four weeks later they found out there was an earthquake. Today, we hear it by radio or television. Who knows what new communications we will get in the future? The artist is not so extraordinary a creature that he knows why his seismographic needle is shaking, it's just shaking. People come to us and ask, "What were you doing?" Now, I will tell you a personal incident that happened a long time ago in Vienna, Austria. I graduated from the master school; I went as far as one could go. Then I was a free artist, a beginner, as I called it. I was in my studio and made what I felt. I was that magnetic needle shaking, why, I didn't know. It was about 1936. Everybody was happy, but I made a figure, a skeleton-like figure, more precisely, a stylized skeleton-like figure. I put a sword in its hand and called it "Fruit of Hate." The name always comes after the birth. It must, because if it is named before, it might be a girl instead of a boy, or vice versa. It is the same with artists. We might get something else, and usually we do. The outcome of the work is just as much a surprise to the artist as it is to the on-

looker, and it should be. If we know everything–what we will do and how it will come out–there is no sense doing it. There's only the sense of showing off that "I know what I am doing." But we don't. It all depends on what you call "knowledge." Is it the knowledge taught only by words, or is it the knowledge from the heart and soul–the knowledge that you can't transform into words? No painting, no sculpture, no music, no emotional impact needs words. What I say in words is the least of what I want to convey to you, but we have to find one way to come close to one another. I do not want to indoctrinate you; you don't have to agree with me. But one thing I know, you will think about it. You will develop your own opinion, and whatever it is, even if you are violently opposed to what I am saying, something will have happened to you that didn't happen before or wouldn't have happened if we hadn't talked to each other.

Now, about perfection. We want to learn in school to draw a perfect drawing or to make a perfect sculpture. We are rather disappointed because we trust a lot in something that we aren't. One can't make a perfect sculpture. One can't make a perfect drawing. No one can, not even Michelangelo! Proof? Most of his works were unfinished. He was seeking much more than he was finding, but he could make a strong statement. That his fragments are masterpieces proves what a genius he was. Imagine what his work would have been like if he had gotten what he wanted. But, as Oscar Wilde says so beautifully, "Man has two tragedies. One is, he doesn't get what he wants. The other is, he gets what he wants." We really don't know what we want, and when we are confronted with it, we don't like it most of the time. Would anyone here, or anywhere, say, "I am a perfect human being"? No one has admitted it so far. Instead we say, "I'm not perfect; I'm human." That's a good answer. Now, how could anyone expect a perfect work, in painting, sculpture, architecture, or whatever, to be done by an imperfect person? It can't be. The work has to have our imperfections,

our failures, as well as our better qualities. As long as it shows something, it is worthwhile. If it looks perfect, it falls into the realm of commercialism, surface treatment, make-believe, dress-up as in the theatre, lovemaking without love! You can't do what you aren't. For better or worse, you have to make your own work. Whether you like it or not, you have to see your own face in the mirror! And, if you paint your face too much, the one who looks at you knows you are painting it too much and might have the wrong impression that you are uglier than you are because you are hiding so much. That happens in art, too, when it looks too perfect. "The technique should never outstrip the performance," said Leonardo da Vinci. He had an outstanding technique, correct. But he still was a great artist. We can learn his technique, but our performance is below the technique. His performance is above it. That's what we can't copy.

I don't believe in dissecting the arts too much. Naturally, if you are a weaver, your strong point is probably weaving. If I am a sculptor, I naturally hope my strongest point is sculpture. That shouldn't exclude other media of art. Take, for instance, the great men. Leonardo was a painter, a sculptor, an architect, a military engineer. His position was that of minister of war to Count Ludovico Sforza (Il Moro) of the fortress of Milan. There he designed war machines to kill people. You can find books full of his plans. The soft, the tender, the fine artist forgot that the machinery he designed killed people. He was just inventing machines. There is a whole museum in Milan devoted to his inventions. Some say he was a greater inventor than artist. He designed a flying machine that almost killed the man who tested it. Leonardo was a scientist and who knows what else. He was also a psychoanalyst. He psychoanalyzed Mona Lisa (called also La Gioconda, 1500-1504) on the canvas, so much so that she died, they say. Had it been two hundred years earlier, Leonardo would have been burned as a sorcerer for taking the soul out of this woman. See what a painting can do?

How deeply he dug into his subject and his art! The "Mona Lisa" was one of the few paintings Leonardo took with him to France. He had to leave Milan because the Sforzas lost to the French in 1499. And that's why the "Mona Lisa" hangs today in the Louvre, and that's why Leonardo is buried in France, near Amboise, not in Italy. I believe Leonardo must have loved Mona Lisa very much, above and beyond average human affections and emotions.

Craftsmanship you can learn if you are clever and if you have patience and talent. Leonardo, who painted as well as other artists, or even better, would not have been the great genius he was if he had not searched further and deeper into the human soul than other artists! Don't be lopsided and excuse yourself when it comes to art. A flutist had better be a good musician, or he will just be making noise. And that goes for every other instrumentalist and for every branch of art. Let's say art is like a big orchestra, and you and I play different instruments, but we must play together to make good music.

The great artists, the soloists, stand on top of a mountain, and where do they go from there? Down. When one stands on the top of the peak, he stands alone. He sees the way down, and he sees it differently because he is up so high. He also sees heaven, if he can get there. So, in his position he can only go down. You have to be very strong to take that! One might not have the energy, courage, endurance, beliefs, and humbleness to do it.

So, do not say, "We are only weavers." This is always an excuse. You should know painting and sculpture; you should know philosophy; you should know medicine; you should know astronomy; you should know! The more you know, the better weaver you are, because that's your profession. Don't exclude yourself, and don't let yourself be excluded from other artists, even though some of us may be small-minded enough to say, "We are painters, sculptors, and real artists, while you are only weavers." Even if it takes twenty years for

your brother-in-law to become a good photographer, he is an artist, too.

It makes no difference how you express your soul and mind as long as you express them. Some say of a sculptor, "He is not an artist; an artist is a painter." I say, "Well, my dear friends, sculpture is three-dimensional and sculpture is almost alive." I let them talk, and I love it. If those who say a sculptor is not an artist had never said it, I never could have answered what I did. It was in me, but I never expressed it before. I said, "You know what? There is a very important book about 7,000 years old that is the foundation of Western civilization. It's the Bible, and in it is written that God took a piece of earth and formed Adam. He did not paint him." That took care of the painters who claim sculptors are not artists!

We are sent into this world with its unlimited beauty, force, and tragedy, and it is up to artists with their limited talents to visualize what they see. One painter will carefully and slowly observe a landscape; another, in almost an emotional fit, will throw the colors on the canvas. It is a highly personal matter how one acts out his creative moments and powers. There are artists who have to have the object in front of them to create the image of it. There are other artists, more modern and contemporary, who paint the events or things they have seen or lived through, creating a visual image consciously or subconsciously.

When I was a young sculptor, I made a portrait bust of the actress Lil Dagover. I sat in her dressing room observing her for an hour as she put on her makeup before her performance. The next day I went to my studio and worked on the portrait bust. I called it a psychological portrait because at that time it was very unusual to do it this way. I felt the artist should only make the impressions that are within himself and therefore work from memory, expressing what he really knows and feels. Looking at the model the next time, he might see more and penetrate deeper into the personality

of the person he models. He might leave the work just as it is, or leave it as his first impressions were, and find out later that they are the best. One can never decide to stop until he sees or feels he has reached the end of his expression of his emotions.

Every piece of art has its own conception and execution; it cannot be copied, not even by the artist himself. Children of the same parents might have a likeness, but they are never the same. There's a difference in them. Each snowflake under a microscope always shows a different pattern, a different composition. Snowflakes are never the same, and we can imagine that there are billions and billions every winter. This is a wonderful example of the richness and creativity of nature, that it creates so much that is always different.

I think that nature is unlimited and undiscovered mostly; we always find new wonders in it. Art and love are extraordinary conditions and very similar. Every object you see, every moment you live is transfigured. It is a created condition. It is like the beetle enclosed in an amber thirteen million years ago that keeps its appearance as evidence of this particular second of its life and existence.

The art of today is to be free, and it is thought that following the almost subconscious flow of lines is much better than adhering to the rigid, learned lines. The academic approach always looks cautious and somehow limited; it doesn't give away your real feelings. When an artist who is well trained in academic methods tries to find himself and has the courage to do so, he is very often surprised at how little he finds there. From then on he might be able to use camouflaging techniques, virtuosity and artistic acrobatics. He never can get enough praise for it, because deep down he feels that it isn't all he can do or all that he is.

When we look at ourselves and remove the fancy clothes of technique, we show our artistic nakedness. Sometimes it is rather meager, but it comes back to us that at least it is ours, our own nakedness. Sometimes we give expression to

thoughts and feelings we were never aware of before, and we are surprised. We don't know whether they are of quality or not. We can't judge, nor can the public, because it is new and unfamiliar to us and to the public. Sometimes it is overrejected. Very often, an artist who finally finds his little own gets violently attacked for it. It takes rather a lot of courage, conviction, and trust to believe in oneself!

We are not even able to judge ourselves, and we can't say of a new work that it is good or not good. This is not the question. Like newborn life, it is here. It is not known if the newborn is good or evil. It has to grow into one or the other. A new life will be exposed to both. Every newborn thing is sometimes ugly and insecure, and as it is exposed to life, it grows in beauty and joy, or in suffering and misery.

I was once in a restaurant with some French and Italian tourists. When I played French music, the French became friendly, and when I played Italian music and operas, the Italians became friendly. After that, any music known or unknown to them they accepted because, through their familiarity with their own music, they trusted me. They felt secure, and everything I played they accepted, including modern compositions. That's how it is in art sometimes. When we exhibit paintings or sculptures that the viewers can understand and in which they can somehow participate, they follow us with more understanding into unknown pieces of art. They may not be enthusiastic about the unfamiliar art, but accept it because they feel sure in following us on the thin plateau of undiscovered areas and values. When they see the work again and again, it looks more familiar, and all of a sudden they can participate in, and enjoy, it. This has happened to me quite often in my life.

One shouldn't just stop at the border of what one knows or is familiar with and never cross over to the new land, the unknown land that is to become known! We should open the windows and let in the fresh air. At least, it's new oxygen. The old air might have been a better air when it was new, but

being used and old, it hasn't a freshness anymore. We are glad to have the new air, even if it is not of the same quality as the last.

The artist needs to know which tools and techniques he needs to express his feelings and love. Acquired techniques with tools have to be reduced in order to find the pure inner emotions, and to come to the expression of one's creative reserves. The search for this expression can reduce the artist to nothing, but, given love, he can be raised up again and again into experiencing a new world–his own world.

When I spoke once at Northwestern University in Evanston, I was asked how an artist experiences critics. I said I thought if they were reporters they were doing their job. Critics who report what happens for a newspaper or magazine can do a good job, but it really doesn't bring the artist, especially the new one, closer to the people. The critics just make the statement for somebody's ear. Critics can write about art with a knowledge of what the great art of the past has taught us, and they are considered good critics by the people who read them because that's what their readers learned when they were educated, too. Some dare even more and write about not only what they know from the past but also what is happening today–contemporary art. The really great artist has a critic of tomorrow. The true critic should not only be a reporter of what we were taught in the past and what we have learned from the present about contemporary feelings, but he should also, at his best, be a prophet who sees something the others don't see yet. He will see something in a work that the artist who made it wasn't aware of at all. The critic, being an educated man and a man who should have advanced feelings and new feelings, should perform the highly sensitive function of a seismograph, noticing and pointing out something far away. The realist, who believes only in the things he sees and hears, would not believe in faraway happenings because there is no real evidence. But that doesn't take away the truth or the existence of happen-

ings. The truth or existence of a happening might come to light some day long after we are gone.

We are told that artists are sometimes exuberant, vivid, and lively, and sometimes too lively and too enthusiastic for sober people. Such people have to consider that artists have a natural stimulation for beauty, for ugliness, for joy, for pain, for love, for hate, which other people experience only when they are taking drugs or drinks, and wander into another world with the help of those things. An artist has a normal quantity of enthusiasm without drugs or drinks, and it should be that way! He should be, in his creative moments, so stimulated that creation makes him drunk. The process of creating puts him in a superdaze or a drunkenness of happiness, or, if he expresses tragedy, in a superportion of suffering and sad feelings. It is difficult for the artist most of the time to come out of those feelings arising from creative moments and face the so-called normal life with other people. Some artists cannot come out of it, and they stay in their world of dreams–dreams that mark the artist as being an artist because he acts out his dreams. Other people have dreams without acting them out, so they just stay dreamers. This is the difference between the active and the passive artist.

In conversation with people, and at almost any party I am invited to, it is said by the doubters, the intelligent doubting people, "What do we do if we believe in the artist and he is fooling us?" They always confront me with Picasso. We have that Picasso monument in Chicago, and some people who don't understand it say, "What happens if he is fooling us?" And I can only say, "Let's assume he is, which I don't believe. Even if he is fooling us or making jokes, we're still lucky to have the monument because we have then the greatest joke by the greatest artist of our time! And that can't be so bad after all." Why are we always afraid we're fooled? Even if the artist intends to fool us, and if he is very artistic, out of his joke comes a real thing. Out of the coincidences

of life lightly and jokingly taken come serious things, most of them against our own will and training. That doesn't change the birth and the existence of a new life, of a new child. And the creativity of such moments does not depend upon the seriousness or the levity of the moment.

To get something from art, contemporary work or future art, we have to trust and believe if we are confronted with it. In every walk of life, in every profession, there are liars, swindlers, four-flushers, impostors, make-believers, even make-believers who make themselves believe. These professions still have their honest members and are judged by their honest members. But when it comes to art, particularly unfamiliar art, the public distrusts it 100 percent and feels righteous in its distrust. It never occurs to people that there might be a few artists who are deep, honest, and serious, and who cannot prove it to others because the proof is in the newness of the experience, and the expression, in the finding of it. Scientists through the ages have discovered things with their hands or with their minds that were previously unknown to others or to themselves. The discoverers knew what they found was new, but they didn't know what to do with it. It took most of the next generation to find a function for the discovery.

I recall the story of the teacher of Professor Lise Meitner, an Austrian physicist, born in Vienna in 1880. She came to Berlin in 1907, and went to Sweden when Hitler took over in 1933. She won the Planck medal for somehow using heavy water. Her professor, Otto Hahn, discovered heavy water many years before and didn't know what to do with it. He saw how talented this young woman was and told her, "I found something, I have something, I don't know what it is, and I don't know what to do with it." It took the next generation to use it. If that happens in science, where something is accepted only when you can prove it scientifically, so how much more it can happen in the more illusive way of art, the nonproven way of art, until somebody feels the impact of it!

About found-object art, I have made such works myself, and still make them. I enjoy it very much. The artist finds something in a pile of junk that once was of use but is no longer, and picks it up. He puts some things together the way a child plays with blocks, and makes his own composition without planning. It surprises him. Sometimes he makes certain things of which he was not aware at the time, and when he looks at them later, they make him aware that thoughts or pictures of that kind were in his mind. Probably he would never have made the piece without playing with those objects, and it is just as artistic and creative!

When we work with a block of stone in the traditional way, we then superimpose our figure or our ideas on it. The stone is just a slave that is molded, and we feel very superior because we put our will on that stone. We play with a block of wood, and it gives us ideas as we carve it. Instead of imposing our preconceived ideas on it, we are led by the wood, as we carve, to a work we had not planned. There was unification between the material and the artist. Sometimes the wood is so beautiful that its beauty exerts a stronger power directly or indirectly on the composition than our will. The same can be true with the stone. Instead of superimposing our design by hacking and grinding it out exactly, we could be led by an inner life, by inner functions. Every rock looks different; every rock is built differently. Its structure remains no matter how you work on it. It's almost like every musical instrument that you play; you have to attach yourself to it or attach it to you. In any case, there has to be a "coming nearer to each other," an integration of both!

A stone should give the feeling of stone, not just stone imitating flesh. Imitation isn't enough. Old-fashioned artists have sometimes told me, "We are honest, very honest; we do exactly what we see." Now, first of all, no one sees the same way as someone else. No one has the same vision, or quality or quantity of vision, as another. *The great visual artist educates us into his vision, and then he is enriching us.* Most of

the time his vision is refused. We don't want to be enriched. Honesty in art is not enough. It is a good thing, but it is not enough. It is good when people are honest, but if we had a whole nation of honest people, there would never be any more creativity or new ideas or new failures. When a person is honest, he is not ready to fail; he doesn't want to know. Artists want to find out, and sometimes the failure of today is the success of tomorrow. The success of today might be the failure of tomorrow. There's really no proof for the realists except the existing quality of honest doings.

I am asked so often about outdoor art shows and fairs. I am glad people are so interested in art now. Years ago, they wouldn't even come and look at it. So, art fairs are an advance, a very good sign. But, when art becomes egocentric, it loses its charm. We find sometimes that a lot of retired businessmen, businesswomen, and retired mothers who are past the menopause have to be great artists all of a sudden. There's nothing wrong with their trying. But the demand and the desire that their art make up for lost time make it a little obvious. One cannot make up lost time in fatherhood or motherhood when one has passed the age for creative power, which can happen unfortunately in creative art as well. Naturally, I would not tie art to any particular age. We had Grandma Moses who started at eighty to paint like a fresh young child. She stayed primitive, naive, and great until she died, and she was a beautiful painter. But she wasn't seeking success or acknowledgment. She was discovered. We found her treasures and her values.

There is always the possibility that out of that vast number of retired businessmen, businesswomen and retired mothers we will get some very good artists. We need a great number of artists to get a few good ones. As my master told me when I was fourteen years old and started carving wood, "Many are called, but few are chosen." It made plenty of sense to me, and I felt good that I was at least one to be called.

It is a great honor to work. To be chosen is a great respon-

sibility, and most of those who don't make it don't know that they could not carry the burden of being chosen. It looks so glamorous when we read the lives of our great men of the past. They had to carry a great cross up a mountain, to the highest point. It is only when one reaches that point that everyone admires him. The great man can only be on the peak of the mountain and he can be the only one standing there. He finds when he is there he's very alone. And where can he go from there? Only down! Most of us find, even going up on a high mountain, that we are not equipped to breathe the air that gets thinner and thinner as we go higher and higher. One has to be special to come to the top, and one is aware of it. Wherever we stand on this mountain, the others will put us in the place where we belong, even if we are fifty or a hundred years gone. And if we are not remembered anymore, we are fertilizer to make other things grow. A lot has to rot so that a lot can grow!

The idea of rotting most of the time is not agreeable or beautiful. Rotting most often produces a bad odor, but still it makes a rose grow and smell very good. We have to give our best to be remembered by generations after us. Otherwise we would be unknown to them. When we show how much we loved this world and how much this world meant to us, they may become curious to read about us. All the values we have treasured, like honor, pride, and self-respect, have to be put on the altar of love for creativity. It shouldn't even be considered a sacrifice. One has to do it. In art, the act of creating is a necessity, and even if it is a sacrifice, we are not aware of it. An artist has to be a giver, not a taker. *He has to give himself freely and without reservation!*

Modern Art and Human Emotions

HE ARTIST IS ONE who cannot live without art; as a human being he cannot live without love. All existing life is yearning for love, therefore let us observe the emotions that create art and the art that creates emotions.

There is a restaurant in Norway with many beautiful, original, and interesting paintings by Edward Munch. One painting shows three people sitting at a table. Two of the persons look as though they are talking to each other, and the expression on the face of one, a lady, is shown quite precisely. The figure talking with her looks a little hazy, and the fellow sitting in the back has no face at all. People say to me, "Why isn't there a face? Why couldn't he paint the face and finish it? What is wrong with the artist?" I have come to the conclusion that when you see people sitting at a distance from you and one looks very interesting to you and catches your eye, you really see a face. The second one may not be so interesting to you, and you don't see so much of his face. The third one might be meaningless, and therefore faceless, unexpressive. This may have been the case with Munch. The third person made no impression on the artist, and therefore no expression came from the artist. If this is so, I think the painting was a very good ex-

Lecture to the American Psychiatric Association, Atlantic City, New Jersey, May 9-13, 1966.

pression of Munch's momentary feelings, and the faceless man interests me from that viewpoint. I have been told that probably Munch meant the man without a face to represent himself. It is very possible.

It is a pity that, in our tradition, we judge artists only by what is there and not by what is not there. The exclusion of motives and details sometimes shows greater artistry than the things people see. It is so hard to convince them, because it seems to them that nothing is nothing. But the nothing is like the pause in music. Silence is also music, and makes the music even stronger; it makes one more aware of the sound when it reappears after a pause. Especially in very emotional music, a pause comes like a resting motion. In a painting, if something is brightly colored, the artist puts a very neutral color next to it, or no color at all. Then the color is strong, convincing, and very artistic. It is also emotional, which it should be.

Art does not need any reasons for being. It is reason in itself. Artists are always asked, "What does it mean, and why did you do it, and for what is it done?" The purer the work is–the more devoid of intentions to please or meet the demands or preconceived ideas of others–the more the reason of the work is in itself. Then, it may fit someone's ideas or not. When art ceases to seek meaning, it sets itself free!

We artists are often asked to interpret or explain a piece of art, perhaps abstract or nonobjective, which we have created out of our inner desires and emotions. We are asked, and rightfully so, when people don't understand it, "What is it?" We retrospectively analyze or rationalize, or try to explain the feelings the artist could have had. I have always had a slight doubt in doing so. It is almost as if one translates a very good thought, written by the creative artist in his native language, into another language so that it may be understood. Every explanation of art is always a translation of something that should not be translated, but should be felt as an original statement in the medium in which it was created. People

have to learn to read something in the original, naturally first through education, and for most of us also by example. Some people have the gift of experiencing art out of their sensitiveness and higher feeling for it. They can do it without any help, by instinct. But most of us, those who need to be guided at first, sooner or later have to throw away the crutch of guidance and walk on our own legs.

To return to the idea of face or no face in the Edward Munch painting: We fully accept, in a photograph that is precise and focused on the people in the foreground, that the people in the background will be out of focus. But when we see this in a painting, we don't like it. We trust the mechanical evidence of a camera much more than the artistic vision of an artist.

The caveman "took to the wall" of his cave to express his feelings, his fears, the mystery of existence, the heroic size of the animals around him. He pictured himself, the only human being in the picture, as small and as being kicked down and off by the animals. Quite an objective observation by the caveman, who, not being superior to his surroundings, had to conquer them by all means. I have almost a religious feeling for those extremely good drawings we call cave paintings. I don't think better pictures of animals were ever made! They are so real, so much of the essence, so much to the concern. The cavemen were fighting the animals, and they were killed by them. But they, in turn, killed the animals and ate them. They clothed themselves with the skin of the animals, and then they put them artistically, without any egocentric or egotistic meaning, on the wall of the cave, probably as an offering to the unknown God. We don't know who the artist was. Maybe he was one who couldn't hunt and fight; maybe he was weaker than the others, or crippled, but very sensitive, and he used his sensitivity in art. The artist could have been a woman who was home all the time. We do not know.

I rather believe the cave artist was a man because men need art more than women do. They need more to create–

woman *is* creation. The artist through the ages is always expressing feelings that rest deep in him and in us. We get restless when we can't express our feelings, we get unhappy, and we finally burst out with it. When we finally see the results, we are still not happy, because the dream and the desire were much greater than what we could create. The artist only puts part of his feelings, emotions, and desires into the work. He puts all in, but all does not come out. It is only a percentage that shows in the work. Therefore, we feel there was much more in Leonardo or Michelangelo or Rodin or the Etruscans or the Egyptians–in all the artists throughout history–than is visible in their works.

We are told, and we have known almost since the beginning of man's existence, that man was created in the image of God. And we find in the art before us that God looks like a man, with a beard, a nose, and eyes, created in the image of mankind. As we get more abstract today, and think in more abstract terms, isn't creative power the image of God? He created us, and we desire to create too. I think that is the strongest proof of his image. Because otherwise, every one of us looks different. Sometimes there are slight variations, and sometimes very strong differences appear among us. Was the pretty one, the handsome one, the good-looking one, or was the sickly one, the crippled one, the ugly one the image of God? We are all his children. Which one did he choose to look like, or did we make the choice without asking him?

In the life of the artist, and of all men, there are the meaningful, fruitful moments and the barren ones. When man is not creative, when the artist has his void time of creative inactivity, he has to live through it and overcome it. This is sometimes harder, much harder, than when he is creative– then he is most natural and active. So we take the creative, working moments, the meaningful moments, with the meaningless, uncreative times, but there must be both. One cannot always be creative. Only a few great geniuses of the past and present were creative and meaningful almost all the time. I

can think of just a few–Mozart, Schubert, Michelangelo, Da Vinci, Picasso.

As an artist gets older, his strength wears out, and he who was a good artist in his young years keeps on repeating his successes by which the world knows him. If he doesn't change in his work, as in life, he gets somehow degenerated. The work has to be new. The artist has to make new things, new compositions, and he must experience new emotions. He must regenerate himself, not degenerate. It is so hard to understand, especially when artists get older, that the works they have done successfully and have worked so hard to produce must finally be set aside, and they must start all over again. They must rejuvenate all the time. Every act of love is a beginning primarily! The necessity of the moment makes the artist inventive, creative, and active. Or, I should say, the inner and outer necessities make him so. Now, how can a sensitive soul explain this to others, when he feels the necessity and they don't, when he feels the necessity of the future and they live in the present? That is why it is so hard for both sides to understand each other. It takes a generation or two for understanding to come, and then the necessity is so clear, the people pick it up as if it were their own and the artist who was not known or appreciated in his own time becomes a very famous artist.

Art is the evidence of selfless deliverance of inner oppressions, tensions, and desires. Followers are never modern artists. They are the so-called academicians. They are mostly liked because they are proven, because the people understand them, but they follow the established fashion, or technique, or style. When we change, we run into difficulties with our fellow man. But for his sake and for our own sakes, we'd better change.

There is the problem in our thinking that an artist must be a man. We have very talented women, young and old, in all branches of art. They seem very pleased when they are told that their paintings or sculptures look like those made

by a man. I am not pleased with this at all, because, first of all, a woman artist is a woman. When she is taught by a man, she follows her teacher and is happy when she is identified with his direction. But what we need in fine art is like what we have in singing: a soprano, an alto, a tenor, a baritone, and a bass. They have their own color of tone, and we need them all. The soprano doesn't have to sing like a man, nor should the bass or the tenor sing like a woman. There wouldn't be any complement, as we know from the past. They had the *castrati,* men who sang the soprano part, because women were not allowed to sing in the church. The *castrati* could reach the heights of a soprano voice, but there wasn't the color–the sound was not like a woman's voice.

So why should a woman artist work like a man? Why should there be a man working like a woman? In art, we have male domination, and it seems to be biologically justified, because of man's greater creative hunger. But we are very much waiting for and seeking the feminine in art. I want the sculpture or the painting to be feminine, not masculine, when it is created by a woman artist. And, by that, I mean the feeling, not the representation. When a woman makes a representation of a man, it should give us an understanding of how a woman sees and experiences a man. It should not be the way the man sees himself, as a muscle-man or a he-man. How do women see us? How do they see the world? We are so hungry, so eager to know. And what we get is a second-hand male, or art that is camouflaged by desire and routine, or even very diligent obedience. We miss the counterpoint, the counterpart.

The feminine in art is very rare or hidden, but we know it was always with us. And it was considered no good. When a person couldn't draw well, people would say, "He draws like a woman," or "like a little child," or "like my little brother." That is a diminishing remark, and I think it is all wrong. The little brother or the little child is much more direct and independent in his impressions, and in his expression

of them. He gives them an awkward or fantastic appearance that is not true to the realism of the grown-up, but rather true to the realism and dreams of the child.

Turning to the art of the child, Dr. Julius Tandler said in his opening speech to the Austrian government in 1918 when he was elected the new minister of education, "Children are born smart; they make them dumb later." Now there is some truth in that–they draw well, as awkward or ugly as it may appear to us. They draw well because they draw according to their feelings and abilities without pretending anything. When grown-ups come and try to teach them or change their viewpoints and their visions, they ruin them! They should let the children improve what they have, not take away what they have and try to bring them over to an adult knowledge or way of doing it.

Now I remember a story about a little Mexican boy who drew shells and fish. He was a young boy, of preschool age, and his drawings were good and beautiful. He loved to draw. He went to the sea every day, and his mother was rather disturbed sometimes because all he wanted were pieces of paper and a pencil to go to the beach. His drawings were discovered by a gallery owner from New York, who had about fifty of them. The gallery owner followed up on the development of that boy. When he came to see what had happened the next year, the boy was going to school. The teacher had told the boy how to draw. The teacher didn't like his primitive, sure way of drawing. So the boy did the only natural thing a born artist could do. He stopped drawing.

We think of children mostly as not finished and of what they do as not finished, or feeble, or childish. And we forget that the body when we are born is a finished body–that it just has to grow. And a lot depends upon the beginning. The same is true in art. A child's art might not look so powerful and so correct and so hopeful as we would want right away. But, as a healthy grown-up has usually gone through many children's diseases, so the growing artist, the artistic child,

must go through the artistic children's diseases to become stronger and better. Those diseases are part of his development and being. They are free associations. The ups and the downs belong to the whole development. You can't count the ups and camouflage the downs, or even try to forget them or bury them, because if you do, they will rot somewhere, and some day they will have to be exposed to air. Children are the "unique beginning," and have the advantage of growth.

Paul Klee said once that he learned so much from children and the insane. I would say the insane person is like a child–a grown-up who can't face the world or take the burden of it, and severs all connections with civilized behavior. All he has left is his childlike being. Now, when we look at modern art and say sometimes that it is childish, we forget that it isn't childish: it is childlike. It is most difficult for a grown-up person, in his grown-up surroundings, to keep his inner creative urges and powers as pure as a child's. This is a great artistic and human achievement.

Shakespeare's Hamlet says, "To be or not to be." This is such a creative expression, so deep and essential. I have the feeling that "to be or not to be" means "to do or not to do," and the artist is definitely the one who does. I am so convinced of it. Every living creature has a heart, and it says, "to do," "to do." If it doesn't, he is not alive any more. It is also on this doing that the artistic life depends.

When an artist becomes too doubtful, or his insecurity is stronger than his instinct to do, how does he overcome it? Doesn't the heart always say, "to do," "to do," sometimes weakly, excitingly, slowly, but always "to do"? So should we.

We are taught, and we learn, that everything we do should be earned. It is the human way of doing it. We can learn, study, surpass fellow students, and become an outstanding student. Then comes a time when we are surprised that we are not the best in this world, because we have worked so hard. We can't earn the status of being a genius. Wisdom and techniques we can learn and earn, but genius is like

sainthood. We cannot earn it; it is given by grace. We can be well-read, informed, and knowledgeable. We could be the best informed in the community or the country–but genius is something else. This is why we shouldn't be disappointed when we work so hard and still are not the greatest. We should earn what we can, and leave room for further developments.

We are so surprised when dreams of childhood, memories of the past, come back to us. It is observed in people who get very old and senile that they don't remember the present but they remember the past. I know a lady almost ninety. When I visited her, she asked me three or four times during the conversation who I was. But she told me stories of the city of Vienna that were correct to the last detail, and she had lived sixty years or more in Chicago. We may consider this a defect, but in modern artists it can be a source of beauty. Marc Chagall remembers vividly the little Russian village of his childhood, the saga, and the ascetic stories of the ghetto. They followed him to Paris and America and back to Paris. They are glorious memories, like fairy tales, and they show up so beautifully in his paintings.

The condition of senility is a burden in the man who did not create and did not work out his problems and dreams in art. But the artist, when he comes to that condition, can benefit by it. We all are artists, by condition, from childhood to the grave. The difference lies in what we do, being driven by inner forces and inner needs. Shall we call it talent, or rather the ability to draw? In my long experience as a teacher at the Art Institute of Chicago, I have seen so-called great talents. On the surface, they were able to draw beautifully for the common taste and the needs of the people, and they became good commercial artists. There is no question that we have need for more than the almost singularly good artist, but artistically speaking not much came from the gift or the clever ability of these artists' hands. They stayed as they were, clever, slick, agreeable, and obeying. There were other

people who were very awkwardly approaching art, naive and sometimes unhappy because they were so awkward. Still, deep down in their souls, their inner drive kept them going and growing, and slowly they grew to their own expression–their own doings, their own way of seeing, and they let us see that they saw.

One day I had a talk in the Art Institute with the conductor of the Chicago Symphony Orchestra, Irving Hoffman, about modern art and music. He is a very intelligent man. Hoffman noted that we just can't follow certain modern artists, for instance, Malevich (Kasimir Malevich, 1878-1935, pioneer of modern abstract painting). In the Museum of Modern Art in New York is Malevich's painting, "White on White." There is only a little square of a different white on a white background. "And," Mr. Hoffman said, "it is nothing." And I said, "I don't think so. First of all, Malevich was a very good and colorful painter; there are other paintings. He must have arrived at the limit–leaving out, selecting less and less color. As Ludwig Mies van der Rohe said rightly, *'weniger ist mehr!'* (less is more). The truth of this statement depends naturally upon what has been done, because if one has very little to say, less becomes less! But the more meaning one possesses and the more he tries to simplify, then that simplification is surely more when it comes out of a rich experience. Now, Malevich almost reached the borderline of color. He painted two different white squares. The next step would be a white painted canvas. Modern painters are doing this now. After all, Malevich's painting was done in 1910. After him, painters now dare to put a white canvas in a show and call it a painting. I think I accept it, when I know who the painter is. Maybe I don't have to know even that; it is a serious experience, an experiment."

Mr. Hoffman didn't agree with me. He told me about something similar in music. "There is the American composer John Cage," he said. "One of his compositions is called 'Four and One-Half Minutes.' At the beginning of the con-

cert, the pianist comes out on the stage and plays Bach, Beethoven, Chopin–very good pieces of music. Then, after the intermission, the people applaud him for what they heard before. He sits down at the open piano, puts his hands down on his legs, sits exactly four and one-half minutes, and leaves. This was the composition," Mr. Hoffman said. "It was a fake."

I thought about that for a little while, and said, "I don't think it's a fake. First of all, you said it was nothing because nothing was done. But there was a full audience with their minds and hearts set to hear music. There was a fully trained and accepted pianist, who sat there four and one-half minutes and thought about music. So a lot did happen without anything being done or heard. And maybe the astonishment, the expectancy that something should happen, the pianist's being there and feeling that the audience wants something from him is rather an inner music. We couldn't do it all the time, but it reminds me of Malevich's white on white, or even white only."

There is a black square, a painting that won a $2,000 prize, hanging at the Chicago Art Institute. People made jokes about it, the newspapers made jokes–$2,000 for a black square! Naturally, the newspapers printed a picture of it, and on the cheap newsprint it really looked like nothing. Most people read the paper and made their judgment from the picture printed in the paper. They also made a very unfavorable judgment about modern art, because this painting won $2,000 for nothing. But it wasn't nothing. It was painted by a very sensitive painter who has been very much concerned about color for years, and who finally arrived at the black square. I looked at the painting, and you can see many, many different shades of black in it if your eyes are sensitive.

The guard who stands by the painting is asked by everyone, "What does it mean and why did it win a prize?" So he asked me, "Mr. Weiner, you know about it, what can I tell

them?" And I said, "As I look at it now, as it hangs here and the light hits it, when it is seen at different times under different lighting conditions, it reflects what shines on it. You will see a lot there. It is not only what is there, it is also what is reflected on it. Black contains all the colors. If we think about it, we can react favorably to certain things, instead of just being critical because we don't understand right away, at first sight. We have to think, we have to feel, we have to let it sink into us, instead of giving a fast judgment and discarding the painting in the first moment we see it."

It is much easier to condemn than to understand. An artist has to be a giver, not a taker. Artists are on the receiving end when they receive the inspiration, the inner need, the inner satisfaction in the giving that is greater than taking. Most people are too busy to give a little love where it is most needed. The artist in his work provides it without knowing it. If you are an artist, you are a lover; if you are a lover, you are a sufferer; if you are a sufferer, you are alive, and a human being. That's what makes artists so human–almost too human!

I have thought for several years about the similarity of drawing and conducting. It occurred to me that unknown numbers of masterpieces were drawn in the air by conductors who made music. The rhythm, the music they feel and think about, must occasionally produce beautiful drawings in the air. I spoke to the conductor of the Augustana Choir, and he agreed to do what I asked, but somehow the photographer couldn't do it. I wanted the director to conduct the piece that he liked and knew best, the one that was closest to his heart, the "Messiah" by Handel, in a dark room with a little light bulb on his baton. Maybe we will do it some day. I won't give up, because I think we might get something quite worthwhile.

An artist never gets old, he only accumulates years! There is a sort of eternal youth in artists; we can observe a sort of unlimited spring in their hearts, even in the middle of winter! The artist is the eternal spring, the eternal creativity of

spring, the eternal growth of summer, the eternal maturity of the autumn. An artist learns a lot of technique, and in the beginning, everyone is concerned about his learning all the techniques and craftsmanship possible. This is good, but these are only the tools to create. One has to live a lot to use them creatively. Live and express and express and live!

We artists shouldn't be too hard on our fellowman. And still we have to speak the truth. And the truth is sometimes brutal or expressed brutally, and that's why most people are afraid of the truth. But it seems to me that one has to confess, and it is hard to do. Most people can confess only when they use brutal power to release the truth. But this is not necessary. They could release the truth gently, accept their own truth, and not make people afraid of it.

In the beginning of a new era in contemporary art of any kind, the truth is at first brutal and rough. It takes so long and so much power to express it, and then people don't accept it. Some are frightened by it, and even feel a certain torture because it goes against their esthetic feelings from the past. It is even hard for an artist to be open and to accept, in spite of the brutal crust, the gold that is inside–the new ideas and new findings!

A young girl, upon reaching puberty, broadcasts or advertises her availability by the way she walks, dresses, talks, moves around, and looks at someone. She might not be aware of it, but the person on the receiving end, the one who is observing and searching, notices. Couldn't we say that a young artist is like the young girl, and that the public should be on the receiving and observing side–the side that is very interested in seeing and reading and taking what the artist has to offer?

When I was a student, I was very much impressed by the Impressionists, who were pretty new for us at the time. I was especially impressed by Van Gogh, by the way he painted, and the way he put his strokes down. Through his way of painting and visual impressions, I saw nature differently

from then on. I saw with the eyes of Van Gogh in ways I hadn't seen before. Every artist from the past or present enriches our vision, and therefore it is up to the artist how much he enriches others, and it is up to his viewers how much they are enriched.

Artists are very much aware of being modern today. We want to be *of* today, and we are aggressively of today and of tomorrow, meaning more than just tomorrow, but even the time after tomorrow. We hardly give a glance at yesterday. If art is only new for the moment, it will be forgotten for the next time. But if it has the newness of the future, then it will not only exist, but also influence the next generation.

Traditional art vocabulary has given way to strictly twentieth-century vocabulary. I mean, we know traditional art. The layman grew up with traditional values; he knows them, loves them, and feels secure with them. He feels secure talking about traditional art, and he feels secure that he is understood. Contemporary art has a different vocabulary, and the layman feels insecure with it. He is not willing to use or learn the new vocabulary, and may even think there is no value in it. But, even if the new one is not as valuable as the old one, we still have to go ahead, because life continues for better or for worse and art continues for better or for worse.

Romantic feelings are nostalgias we engage in when nothing new is challenging us. We look to the past; we feel safe and we feel at home with the familiar. But when we become rebellious, when we have new creative feelings, the romantic feelings leave us and we become bold and courageous. The romantic is always the past, and, as such, it is beautiful. The modern or contemporary is always bold and rebellious, and it is beautiful in this way. They are two different kinds of beauty, like youth and maturity.

Sometimes I tell my students they have to learn to be a failure. They always want to be a success, especially the young Americans. They must be a great success, or else they will drop what they are doing. One can't concentrate on be-

ing a success. One can just concentrate on working and being oneself. One can even be prepared to be a failure. The failure of today might be the success of tomorrow, and the success of today might be the failure of tomorrow!

Even that can be different; the success of today can also be the success of tomorrow, and the failure of today can also be the failure of tomorrow. We still need that failure for development, as a sort of going through the valley to reach the mountain. It is necessary–like children's diseases; they are healthier afterward, as long as they pull through it. The only danger is that one may die–the child in his disease, and the talent of the artist in his failure. So let us beware of dying creatively or physically as long as we can help it.

The demands of art are incompatible. We have artists who are aggressive and loud, and make a lot of noise; they might be good. We have artists who are reserved, quiet, and introverted; they also might be very good. Then, we can have a loudmouth who just makes a lot of noise and is not good, just as we can have a timid, quiet artist who is not good. It all depends on the essential message. In the acoustics of history, the noise adjusts itself to the value of events. As time goes on, the big noise will simmer down and its real value will be evident. And as time goes on, the quiet, subtle voice will gain power and become strong. So I would like to repeat, in the acoustics of history, the noise adjusts itself to the value. In history, the real strength of the message will be adjusted. For the human element, one must be loud according to his temperament; one must retreat if he feels the necessity. Either way, it is not the final judgment. The behavior, the execution, the tempo, the enthusiasm, the egocentricity, the broadmindedness will all even out to their real value!

I saw in the streets of Oslo two young French painters– I presume they were artists–painting on the sidewalk. One was doing the very familiar woman's head with the long neck by Picasso. And I looked at it. It was a really well-drawn copy. The young man used the technique on the whole very

well, and it came to my mind that in the nineteenth century they copied Rembrandt and in the twentieth century they copy Picasso. It was technically harder to copy Rembrandt than to copy Picasso, but both are copies and therefore creatively meaningless, as they will be in the future. The Picasso of the twenty-first century will also be copied by people of lesser imagination and creativity. Copying is just meaningless; it is leaning on someone who has proved himself strong and inventive. The public reacts to the copyist's work as if Picasso did it, and seems to feel that, because the copyist could do so well, he must be as good as Picasso. But this is a superficial attitude, and I am sorry it is so common. Imitation is more admired than invention. Because the invention is already familiar to the people, it becomes a crutch for the copyist. Fifty years ago, artists wouldn't have copied Picasso because Picasso couldn't make his point to the people and why should they copy him? But when art becomes familiar, or as we call it, academic, then the others begin to copy, and they are admired for it. That is the beginning of the end for that style. The new artist has already changed. It takes time again, forty or fifty years, before the public and the copyists catch on to the newer styles and inventions.

A similar adventure in music comes to my mind. When Beethoven wrote his first and second symphonies, they were very well received, because at that time the public already understood Mozart, who was already dead but well established. When Beethoven wrote his Third Symphony, the Eroica, the public didn't like it at all, and they said so. He wrote his first two symphonies in the style of Mozart, and they loved it. Now he was writing something new that they didn't understand and didn't like. And that was exactly when Beethoven started to be Beethoven.

We learn a little bit from each other as we live. First, we learn techniques, but art takes a lot of living and understanding. The inventive artist, especially one who changes styles, is usually a strong rebel. After him come the soft rebels, then

the romantics, then the academicians, and then the wide-spread popularity. Most of the time, that is the end. There are some exceptions, but most of the time when something becomes extremely popular, it is diluted, watered, and polluted by public taste. I don't blame the public; it is the education that the public usually gets–the low-level art, the sweetness, the meaningless objects, the commercial successes dished out by the hundreds of thousands, the art of advertisements, and of religion, too. If we look at the prime of great art, as in the Renaissance, to mention one type closer to us, people were highly educated, highly sensitive, and perceptive to the works of the artist. And it was only in such an artistic climate of understanding, demand, and judgment that geniuses like Michelangelo, Leonardo da Vinci, Raphael, and so on, could grow and blossom. Today we try to educate the public right. Never mind how commercially successful or unsuccessful it might be. The integrity, the wisdom, and the happiness of a nation depend on it.

There is so much goodness in the world that we only have to find it. We have to find it first in ourselves to realize and recognize how much is around us. And the same is true of beauty and creativity and art and music and poetry. Even the ugliness, or what some people call ugly, is very necessary, as the darkness makes us more aware of light. Only out of darkness do we appreciate light. The contrast makes it more valuable. The contrast that makes the contrast is also valuable.

I remember a wine glass falling on the stone floor in a restaurant. I looked at it and saw a fascinating arrangement of broken parts lying there. It was rather artistic, and if I could have picked it up (which one can't) and rearranged it, it would never have been the same. We do such things in modern art, assemblages of things just as they are, and the beauty is as they are. The beauty of that broken glass was not only in how the pieces were organically spread out on the stone floor. As I looked at the arrangement I could almost hear the sound of the explosion again and again. These

spread-out particles also recreated the sound that accompanied the creation at the moment of breakage or destruction. Now, if I painted it, it never could give that message so strongly. If I rearranged it or made the parts myself, it would be second-hand. Art should be first-hand. We need to realize and recognize that happenings like this have to stay as they are. In recognizing it and choosing it as a piece of art, the creative artist, through his activity with it, makes it art! It requires an artist to recognize the beauty of coincidence. It needs a pure artist to leave it unchanged and show it as it is. And it needs a very courageous artist to forget his own ego in his involvement with it–to forget that he had something to do with it indirectly. He did have something to do with it in recognizing the beauty in the impact of the drama, and as such he presents it!

Sometimes I take a paper and scribble on it–I do that quite often–out of an urge to draw. It is completely aimless. Once I examined what I did, and I discovered in the motion and the movements of the drawing what appeared almost like a woman kissing her child. Now, for me, the scribbling is enough, but, for most people, it would be just a scribble. Sometimes to explain it to others I ruin the freshness and purity of the drawing. Then I draw what I see there on top of it, or over it, to make it clearer and more visible to others, who should, in the final analysis, take the time to find it for themselves. I do this for teaching purposes, or in explaining and lecturing. I had no idea beforehand what I was drawing, but what came out reminded me that lately I had seen a pregnant woman. I knew the husband, and we talked about waiting for that baby. Every day they would say, "We're waiting, and it will be very soon now," and so on. So, when I scribbled, this was probably in my mind or in my subconscious, and it came out. It is a wonderful surprise, even if I didn't know it when I started to draw.

Others would like it very much if I said, "Well, I saw a pregnant woman, and therefore I will draw a mother and

child." This would be a preconceived idea, a speculation, a rationalization, and, instead of developing from within, it would have developed from without. The creative moment in us has to come from within, although the impressions and inspirations come from without most of the time. I would also like to point out that a lot of people dislike modern art. They have no imagination; they have to see everything before it is art. The finest things are those we do not see but just perceive.

Art is like a conversation. What one says is just a small part of what he means; just as important are the glances, the speculations, the tensions, the atmosphere. Most important, perhaps, are the things one thinks but does not say. Sometimes we share a silence with people we like or love, and that speaks more than words: a speakable silence! A speakable silence also exists in art. It is up to the observer to decipher the silence.

I made a sculpture, a sitting woman, with her knees drawn up. She had her arms around her knees so that they made an upper circle. My next work was made of a circle only. This would have been meaningless to most people, maybe even to myself, if I hadn't made that woman earlier. The circle alone was now more to me than that sculpture of the woman was before–maybe the association of it is so strong, or maybe the simplification; or maybe the value of the circle that came through and departed from the figure of a sitting woman became universal.

I am often asked what I would have done if I had not become an artist. I can only say there was no choice. If there is a choice, the person is no artist. The artist just has to be one, with no regrets! No sacrifice is too great. That's why artists shouldn't get bitter; some of us do. It was our inner necessity that made us artists, and if the world and its people don't agree with us, it is not their fault or ours.

For instance, I talk to you one day, and ten days later something about our meeting might show up in a picture or

sculpture. It comes up even if I am not thinking about you at all. I choose what is inside me, and I am surprised by what comes out. It reminds me of our meeting, or of things I saw, or of feelings I experienced. Sometimes it is an agreeable surprise. Other times it is a disagreeable surprise to be reminded of sad events or exciting happenings that I had forgotten and that are still in me. In any case, agreeable or disagreeable, it is a surprise to me and therefore a statement from within.

Sometimes, not too often, people don't agree with what I say in a lecture or with what I write, and this is fine. I talk to people to expose them to thoughts about modern art and emotions and what it's all about. Even if they disagree, I am successful, because to disagree they have to think about it, and this is what I want. Let them think their own thoughts and make their own decisions. If they are prejudiced in their thoughts, it shows who they are. They give themselves away by their judgment, by their taste or their tastelessness. They think they judge the artist, when actually they judge themselves. They are judged by their judgment and are exposed by it.

If you love a thing, even defeat is part of it; it is also welcome. It goes to the deepest meaning of your being. And it might bring up feelings and emotions which affection or joy might not bring out. It is like black and white, and all the colors in between which make an interesting palette. An artist can take warm colors, and they complement each other. He can take cool colors, and enough cool colors with low temperature can add up to warmth. He can place cool colors with warm colors and sort of give the feeling of affection and love, and he can take warm colors to complement each other and make a feeling of ecstasy. He plays–I don't like the word play as it is used–he lets the colors confront each other, and come closer to each other, in unity. And the result is always something new, something for the next generation.

It is a satisfying feeling to try to put down my thoughts on

modern art and human emotions. I cannot always command
my thoughts toward it. Sometimes thoughts come at odd
times, and sometimes they are so strong and clear and gen-
uine. Then, when they are written down, they don't sound or
feel the same way. One cannot always speculate what is good
and what is not, what is important or not. Our judgment of
the moment is not always correct, and time and events prove
later what was of value.

The especially sensitive and sharp mind might make the
right judgment in a split second, especially in art! You see
a piece of art, and right away, in spite of its newness or
strangeness, almost its impossibility, you feel the value of it.
Right away, we artists welcome curators, museum directors,
collectors, and other people with such qualities, for they are
the ones who detect the unknown value and make it known.
It takes a while for the public to know.

El Greco was forgotten for three hundred years. His paint-
ings were stored away–I'm glad they were not destroyed.
The German art historian and art critic Walter Meier Graefe
(Edward Munch painted a picture of him), whom I admire
greatly, was sent to Spain to write a book on Goya. He saw
El Greco's paintings and came back with a book on El Gre-
co. That was at the end of the last century. Since then, there
isn't a museum of importance anywhere in the world that
doesn't have a painting by El Greco and isn't proud to have
it. Without the foresight of the art historian, the world might
have had to wait another hundred years. The paintings
would have been discovered–nothing gets lost in this world
–but the question is, when?

The discovery of El Greco changed the history of painting.
Modern artists, impressionists and expressionists, adopted
El Greco as their leading artist, even if he did paint three
hundred years before them. There was something in his
paintings that gave them the courage to go ahead with their
own ideas of painting. Two important painters of the past
had a great influence on the impressionists and expressionists–

El Greco and Goya. Without them, the impressionistic movement would not have been so strong. Their ideas were extremely new, but the artists needed something for their backbone, some support, something to hold them, and that's what they got from those two.

Today we have Picasso. He is the backbone of contemporary art. Whatever happens after him, we are fortified and strengthened by him. His influence is enormous, directly or indirectly. And that is what will help modern art to carry on.

Picasso is not the only one. There are so many others, but Picasso is well known for, and his whole life is dedicated to, the newness of ideas and the freedom of new ideas, whatever they are. In music, we would look toward Stravinsky or Bela Bartok or Schönberg. We are very grateful for men like these.

We lose a lot when we start criticizing or analyzing artists such as Picasso, and saying "I don't like this or that," and "This or that is good." It is good to analyze, to dissect in order to know. But never forget that, when you dissect, you dissect a corpse and you only get wisdom from a dead body. You have to keep in mind the much greater impact of the unity of life—a body alive, an artist alive, with all the pluses and minuses. If you dissect too much, you have details, little parts; you know about it, but you lose the unity of the whole. Use the knowledge of dissection to reinforce and strengthen the unity of life!

As I started to say at the beginning of this meeting: Ladies and Gentlemen; You will witness a birth of a lecture!

Lecture in St. Paul Lutheran Church

MOUNT PROSPECT, ILLINOIS, 1966

HEN I WAS TEN YEARS OLD, my mother sent me and my two older brothers to the music school to learn to play the piano. At first, I didn't like it, but I went. On the street where we were living, there was a girl about twenty years old who played the piano. Her brother played the violin. I don't know if my mother sent us this way on purpose or not, but we would often walk past their house. As we passed by, we would listen to them playing Haydn, Mozart, and Beethoven, and I was very impressed, especially with the young woman–she was very beautiful. I think a little boy of ten can fall in love, and I might have fallen in love with her. So, when my mother said, "Don't you want to take piano lessons?" I said, "Yes!"

I didn't like practicing the piano, but I had said yes. As I analyze it now, at that time I really didn't know what I wanted. I was then very eager, and in the next week or two when we passed the girl's house, I knocked on the window and said, "I'm taking piano lessons!" So that was my contact with music, and I kept it up. My mother played too, but she alone couldn't make me play; that event with the young lady did.

When I was fourteen, I wanted to do something else. I wanted to form something. I fell in love with a girl, although

52

she didn't know it. I looked at her and thought, "That is fine! If I marry her, we'll have a house and a garden, and I will make marvelous figures to put in the garden like the ones we saw at the castle of Schönbrunn"–the castle of Emperor Franz Joseph I in Vienna. I dreamed that all the time. So I had to be a sculptor, and I still am! Could we say that love brought me to it, and kept me there? I think love is still the driving force.

My father sold wood and wood veneers. And I started in sculpture as a wood carver. My first material was wood. I still love it. As I always point out, wood is almost like life itself. It's warm, it responds. With stone, the artist touches half of eternity. There are fossils in it; it is cold. It's harder to work with than wood. But when you get something done in stone, then you feel you really have gotten somewhere.

My first acquaintance with wood was a very interesting one. My mother had to be in the store when my father went around to get piano makers and carpenters to buy his wood. That is not done in the United States. There were independent carpenters and piano makers in Vienna, and they went to small shops to buy their wood and veneer. With the big lumber yards and veneer companies and furniture marts here, it is a different thing. There, it was more individual. A carpenter would make a table and for him, carpentry, furniture making, was his whole life. There were carpenters who made altars, and they were beautiful. When I see them cut and ready-made here, I don't like it. There is no integration of the person, there is no love. There is only making a thing to sell it. And you know what we call it when someone makes a thing only to sell it, with no love involved–prostitution.

My mother, who was a small woman, was alone in the shop most of the time. When I was a baby, she would take me to the shop with her. One day a carpenter came in and said, "I want some of that veneer." So there I was, and what should she do? She wasn't such a new mother anymore: I was the third boy. She took me up in a bundle and put me

up high on the veneer pile so I wouldn't be in the way. She put two bundles beside me so I wouldn't roll. And that was fine–it worked for months. One day a carpenter or piano maker said, "I want that veneer from up there." She put me somewhere else, and said, "Can you help me?" The gentleman lifted the veneer down, and they saw then that it was all warped! That was my first contact with wood. That was when I began to work with wood!

I got through school, which was necessary according to the law, and then I decided at fourteen to be a sculptor. I came to a wood carver as an apprentice, dreaming of carving figures. My master knew I wanted to carve figures, and every time there was a figure needed in the composition of an ornament, he let me do it. I wasn't very good at the beginning. But I was with the wood carver four years, and then three years in the school of arts and crafts, and then six years in the academy of fine arts, through the master's degree. That was some education. So, after thirteen years of studying, I came out and thought I was a beginner.

I meet people who take a private course for half a year with some teacher, and say, "I'm an artist! I'm a sculptor!" It's the evaluation we put on it. Now, even though I make it my whole life, I sometimes hesitate to say I am a sculptor, because Michelangelo was also what we call a sculptor, and look at the difference.

Art is only art when it is creative. And the first, the number one creation, I call a human life. Second is the substitute for it, which is practiced mostly by men–that is being an artist. Women usually marry and have children. After their children are grown, they are in the situation we men were in when we were twenty. But, when they were twenty, they didn't think of art–they thought of creative things–life, a child. We male artists are not smarter than women, we're not better, but we start out much sooner than they. When a girl is ten or fourteen, she doesn't think about art. She has her dolls, and those are her babies, and she is thinking probably

of Prince Charming. And that's fine! We men are already in-
spired, and falling in love with any female who runs across
our way, and what shall we do? Art!

So we men are already about twenty or thirty years ahead
of women as artists. When women's lives are fulfilled and
their years of maternity come to an end, they want to be art-
ists. They are very determined. I admire them for it.

What I can't share with women is their insisting that they
have to be as good as the male artists. The women artists are
better than we could be in that short time. You see, it's not
prejudice–we honor and appreciate women artists very
much. I think there is an unwritten chapter in the history of
women's liberation, especially in the visual arts, especially
in sculpture. The femininity of art is missing.

We have had a very good sculptress, Käthe Kollwitz. She
was first a good graphic artist. Her husband was a doctor of
socialized medicine. That is a specialty they practiced all over
Europe at one time, and they still do. Her husband practiced
socialized medicine in the poor districts, and he got little pay
for treating the poor people. Käthe was quite a warm and
artistic woman. She went with him on his calls, and she drew
the poor and the sick and the dying, and the drowning, sui-
cidal people. If you ever see her book, you will walk through
the misery of life; the evidence is there. Now, she was one
first-class artist. She was also a sculptress. One of the finest
World War I monuments for the dead soldiers was created
by her. She modeled it in clay, and then it was cast in bronze.
If it was too big, and she was a small woman, she could
have had a helper. If it was in stone or wood, she could have
had helpers.

Sometimes, like Malvina Hoffman, an artist can have too
many helpers. Her helpers made everything that she wanted,
but we don't find her, her own touch, in the wood and the
stone. That is the danger. Men also do this. We have good
sculptors, but they are weak or tubercular, and they are not
allowed to do the heavy work. So they say, "Hey, come here,

you clever guy—clever enough to do what I tell you, but not clever enough to be on your own—you have muscles, you are strong enough, get in there and make it!" But, when we see the work, the spirit is not in it.

I can give a good example of the opposite result from the life of the painter Renoir, the painter of those lovely porcelain-like faces and beautiful heads and flowers. He painted to the taste of most of the people, but he was also a sculptor, though he did little of it. His bigger sculptures, which are very famous now, were done when his hands were already crippled with arthritis. Renoir had what we call a factotum, a man who was very clever technically and who could work in clay, in wood, or in stone. So Renoir, with his crippled hands, would walk around with a stick in his hand and say, "You make this and this," and he guided his helper as a conductor guides his orchestra. When the sculptures were finished, they looked like Renoir's sculptures!

A conductor gets the sound out of the violinists without playing the violin. It takes a strong, leading personality. Now, we always have business people and speculators around us who would say, "Why, Renoir is old, Renoir is crippled. When he dies, we will catch that fellow who does all the work, and he will make the Renoirs we need." It's clever thinking; it's realistic thinking, as much as a realist can think! But, when Renoir died and they offered his helper money, he got a big studio and a helper, and he worked. What he produced didn't look like Renoir. It couldn't be used. The spirit was gone. So, even though Renoir never touched those works, they were all his. See how complex art and artists are?

If I were an artist with experience but a less strong personality than Renoir's and you were my young, strong helper to whom I said, "Carve that wood," or "Do this," or "Do that," it might look like nothing. It would not be your fault; it would be my fault. I wasn't strong enough spiritually to use you as a tool, which is the only way I should use you.

And if you, as my helper, are artist enough, you would re-
fuse to be used, because if you are only half an artist, you
would want at least to be your own half, not a full slave to
me.

I call Picasso a religious artist. I call every creative artist
a religious artist. You have to forget the denominations.
There was art before Christianity. The Bible also precedes
Christianity, or at least the Old Testament part of it. We
can't start the history of mankind with Christianity. I don't
even think that was the purpose. Christianity's function was
only redemption. The world had to exist a long time to de-
velop and be sinful enough to be redeemed. So it was old al-
ready when we got Christianity. All those artists who hoped
for it, who felt it, who didn't even know for what they hoped,
were religious artists. I would even call them pre-Christian
artists in my terminology. If we think Christianity is such an
all-around belief of mankind, then it must have had its seeds
before Christ, and Christ must have existed before he came
into this world. Christianity is only recorded at the time
when the Word became flesh; but the longing, the seeking,
the feeling, even the most primitive way of searching, I would
associate with Christianity!

Therefore, let's observe Picasso. His lips said he was a
nonbeliever. His lips also said he was a Communist. *[In his
life, he made the heads of Christ, Mary, and about twelve
drawings of crucifixions with bulls and horses around them in
a book about bullfighting (1959). He also painted a cruci-
fixion scene in oil (Golgotha) that is abstract and cubistic.]
That's all I have seen of his that is really religious in theme.
He could excuse himself even that by saying that when some-
one grows up in Roman Catholic Spain, as Picasso did, he
can't help it, he sees it and he does it. But everything he did
showed the deepest concern about creation, about mankind,
about man's suffering, about war and pestilence—all that we
read in the Bible, all that has concerned us for ages. So his
work is that of a believer, and his lips were lying, which I

rather prefer to the lip service paid to belief in most churches of all denominations when the inside is not creative, is meaningless. We have a so-called religious artist who sells his images of Christ by the millions, and though, as a man, he may be a fine Christian gentleman, what he paints is lip service; it is the Lord's Prayer said by someone who knows only the words. I prefer Picasso!

The second thing Picasso said is that he was a Communist. What kind of Communist could he have been? He was a millionaire living in a castle, and he did not give his millions to the poor people. He created art, which is against the party line of Communist Russia. So what kind of Communist was he? He was the same sort of Communist as he was a nonbeliever. His lips were lying, and I love him for that. I will give you an example.

Chicago has a monument given by Picasso. It's a gift of kindness and creativity to us because he didn't need money; he had it. He didn't need fame; he had it. He wanted to tell us something.

Before the monument was put up, there were pictures of the models in the newspapers, and there were criticisms of it. I saw the models on exhibit for a week at the Art Institute, where I taught every day. And did I hear criticisms! When there is an exhibit at the Art Institute, I usually say to the guards, "Let me in before the people come in, because their remarks disturb me. They are so vicious–not even vicious, dumb–really dumb." I say, "I want to be alone to read it, to see what is there." So the guards let me in alone, like one of the prophets who thinks best in the desert.

People who were more familiar with Picasso's work saw in the statue from the side a sort of profile of a woman in his usual manner. Those were the kind, trying people. The others said, "Oh, it's a vulture." That it could be. But how many knew? Those who saw it as a vulture took it as an insult– "He thinks we're vultures, bloody." The trouble is we're not educated enough, or not willing to be educated enough, to

know what he meant by it, even if it is a vulture. You see, since Picasso turned to the Africans and to old art, he was probably familiar with the worship by the Egyptians of the vulture that was a symbol for womanhood and motherhood. Let's assume he meant that. What a noble idea to give it to us! Maybe he thought of Chicago as the mother of the United States. Maybe he thought of New York as the father. If I told him that, he would say, "Oh, no." It doesn't matter. Sometimes the artist doesn't know what he meant. The greater the artist, the more there is in his art beyond his own comprehension.

One thing is true—we have the vulture, or whatever it is. It may be a bird; parts of it look like wings. If they are not wings, they look like them. When I looked at the models, I tried to imagine the sun hitting the statue from all sides according to the time of day. As the sun goes up in the morning and as it goes down in the afternoon, you can imagine the changes. There will be a moment when the sun will face the front of the sculpture, and the light will cast a shadow somewhere on the pavement behind. I thought, "It will look like the silhouettes of the tablets on which the Ten Commandments are written, and if he likes it or not, it is the Ten Commandments. I might be mistaken, but I can't see how. Somewhere, somehow at a certain minute of the day, those Ten Commandments must be on the sidewalk. And it is usually the sensitive or the religious people who might find them, who would look for them, instead of saying, 'I don't like that crazy thing!'"

I want to say something about Georges Seurat. You know his painting "La Grande Jatte," or what they call "Sunday Afternoon on the Seine," the biggest picture by Seurat. Even if you don't know the title or the name of the painter, you know the picture. I'm sure you have seen it on hundreds of postcards. There is a woman in an old-fashioned dress with the nice waistline of the time (though they paid dearly for it, you know) walking near the Seine. And there is the water, and there are the people, and there is a dog playing, and a

man with a top hat and a beard. It is a very nice and amusing picture. What I want to point out is that Seurat had an idea of painting, a certain idea–pointillism. He made dots. For this, he was attacked; they said, "It isn't painting," just as to-day they say "Calder's mobiles are not sculpture." Seurat said, "All right, I am not a painter–I am a scientist, and I make dots." They called it pointillism. Seurat was so proud of it, he said, "I am a scientist to figure it out." But he was a genius as a painter, I can tell you that. He died when he was only thirty-one. So what does it matter what people call us? They have called us worse names. Calder calls his sculptures "mobiles." Who cares what the title is? What Seurat painted was dots. He made yellow dots, and blue dots, and if you look closely, that is what you will see. But you step back, and the meadow is green! He didn't use green. Your eyes are mixing the colors. Whether you want to be or not, you are a participant–you are active. I call Seurat "the father of the conception of modern art."

Seurat's work is more than just a pretty painting. Just as with Rembrandt, the greatest master we have had, you wouldn't say, "Oh, it's lovely; it looks like St. Paul, or St. Peter, and the prophets." There is much more behind his work than that, much more which most people don't see. If there hadn't been, it wouldn't have lasted 300 years–not even thirty years. If the appearance is agreeable to us, we say we understand Rembrandt. We see a man, a prophet, but there's so much behind it, and the viewer doesn't even try to get it. It is enough that it is a nice picture. But what makes the difference between Rembrandt or a very great illustrator of our time is the meaning behind the work, the poetry between the lines. It is the thoughts behind your forehead when you look at another person, and you just say, "Oh, that's nice, you're lovely," and you show a flat face because it's meaningless. And another time you look and say nothing, and the other person gets your attention.

Robert Oppenheimer, the physicist, once said so beauti-

fully, "The things we don't understand we try to explain to each other." When I read that years ago it hit me that this is the essence. When you love somebody else, and that somebody else loves you, what do you have to say? You look at each other—you know it. When you don't know, you ask five times a day, "Do you love me?" And he says, "Yes, dear." Meaningless? You ask, you are insecure; he says, "Yes" so as not to be in trouble. Meaningless!

It is the same with art! You must read between the lines. You have to feel it! You have to experience it. And whether you want to or not, your eyes are working with Seurat, who for that reason was a scientist. Scientifically, he plotted how to force your eyes to mix the colors. And, if you want to understand modern art, you will have to mix the colors not only with your eyes, but also with your brain, your heart, your soul, and with the known, the unknown, the unseen, the unheard. And there is no limitation to that!

Marshall McLuhan has talked about a "cool" medium— that one has to be involved in. He used an example—Picasso's "Woman in a Chair." One looks at it, and there is no way to see the woman in the chair. But she is there! And, to make us see that, the artist has caused us to become involved with his painting.

Before Picasso, a chair would have been a chair. And, now, I see these elaborate chairs—the woman doesn't even have to be sitting in one. This is a woman, and she invites us to sit down. Look how important a chair can be!

Most of our realists, when they see a real woman, don't know they have seen one. So how can they see a woman in a chair?

We have too many doubting Thomases. We always have had. Now, there is a joke—because if you see it, you can touch it. But the joke is here too—if we have it in the pocket, we still have it. And then people say, "But what do I do if the artist is fooling me?"

Well, the thieves, the liars, the murderers, the four-flush-

ers, and the betrayers have always been with us. We have them with us now, and future generations will have them after us. If we are afraid to do anything, or to believe a little bit in the unseen, because somebody might fool us, we might not be fooled our whole life, but we will also lose our life. I would rather be fooled occasionally and not miss the truth.

Sometimes a liar starts out purposely to tell a lie, but his inside is more truthful than he knows (like Picasso when he says he doesn't believe). The liar says the truth without wanting or knowing it; and the truth, for once, says something is a lie without wanting or knowing it. It is up to us to evaluate. Not because a person is usually truthful will he always say the truth, nor will the person who lies most of the time always lie. Somewhere, somehow, we are imperfect. That is why we are here, that's why we need redemption. If we were perfect, why would we need redemption? For what do we need to be redeemed?

(QUESTION: Egon, sometimes you read about how suffering affects the thought patterns of people and of artists. I wonder, in your philosophy and in the way you view things, what role suffering has played in shaping your thoughts and in shaping your work. I know that you lived through and witnessed some of the war.)

I ask myself the same question. We have read of artists who were mediocre as long as they had good times. When misery came to them, they were great. During World War I, and just before World War II, when things became very chaotic, I saw what happened to my friends, and I came to the conclusion that, in bad times, the good one gets better and the bad one gets worse. This showed up under the stress and strain of suffering. Probably, under stress, the good artist becomes better, and the mediocre one gets worse. So I would not prescribe suffering for everyone who wished to become an artist. They might suffer and still not succeed.

The real feeling of suffering, probably even in the good ones, is that suffering reminds us of death. When we feel that

we should die soon, we won't look for lies and excuses. If an artist knows a work is his last, he will say, "All right, I have made jokes long enough; now I want to say a serious thing." So suffering somehow reminds us of death, and that's probably where the power of suffering lies. After all, why did Christ sweat blood? He didn't have to do that. He knew what would happen, He knew He would come through. He wanted to go through the human suffering all the way. Where is the sense that the Word became flesh, if He could have avoided all the suffering? He could have stayed where He was before. I would not say to an artist, "Look for suffering," but if you are an artist, you are touched by it anyway.

I was with Doris Butler, an art critic for the *Chicago Daily News,* at the Methodist Church in Aurora, Illinois once, judging a religious show. As we sat at dinner, Doris, who had just returned from a trip all around the world, was asked what she saw in India. She said the poverty and hunger were so shocking she couldn't sleep. They were starving, begging, and the person who was with her said, "Please, don't be touched. There is no end to it. You give to one, and there come four hundred more. And it won't help them." I can't forget what she said. It bothers me. I probably will get rid of this feeling by making a drawing or something. See, artists are lucky. We are the ones who should be grateful. If I am bothered by something, I can finally get rid of it. When some of my friends come and say, "Ah, the world is wrong; they treat me wrong; I am an artist," I say, "You have plenty. Don't complain!"

Mrs. Butler told a story on Sunday that is eating me up. One day she was walking around and a mother threw a baby in her face, so to speak, a baby with no arms. Imagine how she felt, she herself a mother of grown-up children, when she saw this. When she offered help, people said, "Stop. Those are generations of beggars who maim their children to beg." Do you know what's working on me? First, I see that kid in my imagination, and I think it must be a healthy kid, or it

would die. Then I think, "What mother or father would do that?" I don't know what I will do about it, but I have to produce something, because it bothers me. Can you visualize that? Did you expect a story like that? They also told her, "They are generations of beggars, and they are proud of it!" So probably in their minds it is like circumcision for the Semitic people. Who knows? They think they are right, and what is right and what is wrong?

Can you imagine seeing a baby like this? The sight doesn't leave me. I get it out of my system in art. And when people see a piece of art, they say, "What's the matter with that guy? He must be sick! He is cruel; he is sick." It isn't we who are sick at first—it is the world as we record it. And I must say, in living it and recording it, we can get very sick ourselves. Doctors treat contagious diseases, and some of them die from the diseases they try to cure. The same can happen to us, and does happen. When an artist finally collapses, and isn't strong enough to go on, he is the crazy artist: "Look what he did—he must be crazy."

An artist must be very strong, physically and mentally, very sensitive on the inside. I could use a nut as an analogy. The outside is very strong and hard, and the inside soft. And this is the dangerous and difficult thing with human beings. Some people get very hard to protect themselves, and it isn't only on the outside. They get hard inside, too. Then they live longer, exist longer in flesh. Others begin hard on the outside and soft on the inside, and they get softer as life defeats them. They are more sensitive. Their outside gets softer instead of harder, and finally they collapse. The best of them sometimes collapse. Those who succeed are still not sensitive enough. That is the question, to succeed or not—or, as Hamlet says, "to be or not to be."

Picasso says we are ugly, and we hate the guy for it, but he says the truth. I hear people say art has to be beautiful. But beauty has wide variations. If we love life, even the ugliness is beautiful, like day and night. Most people like the

light and the daytime, and they don't want the existence of night, because they sleep anyway. They're lucky, those who do. But there is beauty in the darkness. There is a light in the darkness. There is a darkness in the light.

What is beautiful, and what is ugly? Most say, if it's dark, it's ugly; if it's light, it's beautiful. That is not the way it should be. When you go deeper, all of a sudden you find beauty in a different sense–a beauty of inner experience. Prettyness in art is like saccharine. There is in us an existing need for natural sugar, but when we use saccharine instead, it becomes so oversweet that it even tastes bitter. That is the way it is in art.

In *Life* magazine recently, there was an interview with Anna Freud. A sculptor had done a bust of her father, Sigmund, and she said that she didn't like it.

The sculptor was I! First of all, Anna Freud didn't say that because she didn't see the bust. They didn't show it to her; they were afraid. It was said by a woman doctor with her. But let's assume she would have said it, which is possible. How can I see Freud as she saw him? He was her father, and Anna was his smart daughter. He always said, "I would have liked my sons to be like her." But he got sons, and they were just males, and he got daughters and they were smart. Even Freud couldn't change that. First, he was disappointed; then he poured out all his knowledge on her. We should be very grateful for that–she is a real doctor and scientist. Whatever an artist might do could not possibly fit her image of her father, and if it did, it might not be art. This is not putting her down, or putting ourselves up, but art is not always one's personal, favorable image.

We never can please a mother when we make a portrait of her child. We never can please a husband with a portrait of his wife, and we shouldn't. If I were to make a portrait of a gentleman's wife and I felt as he does about her, I should take her away from him. You know, sometimes it happens.

Now I will tell you a story about a portrait bust of Leo

Slezak, the great singer who sang sixteen times at the Metro-
politan Opera with Caruso. I had the honor as a young artist
to make a portrait bust of him as Otello, his greatest role,
when he was sixty years old. When I had it finished, and I
thought I had put everything in it at the time, which I had,
Mrs. Slezak said, "Mr. Weiner, I like it but there is, just
around the mouth, something." You know when you make
portraits, there is always a relative who says the eye isn't
right, the ear isn't right, the mouth isn't right. She said, "You
know, Mr. Weiner, as I see Leo, the mouth is different. I
don't say it's bad, but it's different." And somewhere, some-
how I must have had a guardian angel, because the thoughts
came fast. I said, "Mrs. Slezak, I agree with you fully. I
could not see the mouth of your husband as you do, because
I think he loves you, and he must have kissed you five hun-
dred thousand times. How could I make that mouth what you
see? I couldn't." It's no joke. How could I? Besides, I look
at him as a man would and she looked at him as a woman
would. How could we see the same? If we do, the thing is at
best a photo. And even photos aren't so mechanical. People
often say of a photo, "That doesn't look like me!"

I always ask, "Who was standing there?"

"Well, I was there, but that doesn't look like me."

Then comes a pretty picture, and people say, "Ah! That
looks like me–make several copies."

There was a painter by the name of Angeli. He had a one-
man show in the Künstlerhaus, the art institute of Vienna. In
his show were many paintings of Count So-and-So, and Prin-
cess So-and-So, and Baron So-and-So. Besides being paint-
ings of the big shots of nobility, these paintings were good.
He was asked by many of his colleagues, who also were great
painters, "Angeli, how can you get portrait commissions,
satisfy the customer, and make good paintings? With us,
when we satisfy the customer, the painting loses because we
do what they say, or we don't like the person who sits with
us for a portrait, and we don't even make a good painting.

How come you can do that?" He said, "I tell you, I have been doing it for years, and here's how it goes. I get a portrait commission of Baroness Lichnovsky. The Baroness comes for sittings. I like her, I paint what I feel, and I am experienced. I must sort of like the person, and occasionally these people are very good-looking, agreeable, and cultured. Let's say the baroness wears her hair so that both ears show. I paint one ear a little faulty, or one hand, or one finger, or, if she is décolleté, one elbow—something not quite up to the final aim. Then the family comes to look at it, and one says, 'The nose isn't right,' and another says, 'The eyes aren't right,' and so on. Then one of the smarter ones discovers that ear, or that finger. Then they all look at it. They agree, 'Yes, that's wrong,' and they make a big fuss. Then I say, 'Ladies and gentlemen, I think you are correct. I will change the ear.' They forget all about the rest."

At an exhibition the pictures I like, the pictures that present no problems for me, are the pictures I look at for half a minute and pass on because I almost know all about them. But those pictures I don't like, the ones that disturb me, I study for hours to learn what is there, what this one has to tell me. Later, I find, most of the time, that there was more in it.

We always say, "Easy come, easy go," don't we? I look at a picture and love it: Easy come, easy go. A man sees a good-looking girl, or a girl sees a good-looking man, and they say, "I love you; I'll marry you." Easy come, easy go, if you marry on looks alone. If we are always right in what we like, why do we have so many divorces?

I am often asked how mothers and fathers can guide their children better in self-expression. I say, by not influencing them to do the things you failed to do. We say to ourselves, "I was a poor fellow, but my child will be smarter because I earn money and I send him to the university." We never think that that child might not be the material for a university. We leave it to others to kick him out and then say, "They

didn't take him." When we make money and work for our children, why do they have to be smart? Who says so? You say, "I couldn't paint, but my kid is going to." So you buy him colors, and say, "My dear, you do it *this* way." When children play in the mud, we don't tell them how. When they smear the walls, we spank them, but those are their paintings. That is how we ruin them when we say, "Don't do it like that; do it this way!"

You know what I miss? (This is not kind, or maybe it is.) Seeing and hearing a woman when she gives birth to a child. She feels the pain and she cries out–if one could paint it, it would be a masterpiece for sure, because the music she makes when she yells or cries is original. Whatever it is, this is what we artists are yearning for; this is what we are missing. Women go to hospitals, and the experience gets lost– the most emotional part of the whole thing.

Maybe there would be fewer divorces if the men could see their wives in childbirth, because strangely enough women forget it. They are made to forget it, because they wouldn't have a second child if they remembered the pain. But men never forget those things. Women have to be able to forget because they have to go on. Birth is not the function of men, and they don't forget. Why can't it be shared with them? I tell you, this will change.

Lecture to Art Teachers (Evanston)
With Slides of "The Pillar of Fire"

REATIVITY IS A THING that is in all of us, or we wouldn't be here. This is the main drive. Most of us stay on that road, fulfill that biological creativity, and that is that. When they say, "I am not artistic and I can't do a thing," I don't believe it at all. We are all artistic, and we started artistically because we were the object of a creative moment.

Most people grow up and get another education. Art was once thought unimportant. Thank God we have art education now. It's very important. There is nothing sissy about art at all–on the contrary, it is an enormous challenge; it takes courage. And even if you don't have to fight the difficulties in life, you fight even more difficult things in art.

I have my students start out modeling a face. They draw it in clay. I say, "You are making it as if you were drawing lines with a pencil, or painting in clay. Why do you work in clay? You could just as well paint, and this isn't painting." They have to attack the space, and that takes courage. The three-dimensional feeling, the third dimension is attacking space, forward this way, in space! It takes courage.

They all look at the head when we have portrait sessions, and they model the head after the model and what they see. They look at the face, and as they model, I tell them, "Start

with an egg. It's a round object, as is the universe, or you yourself." They start with the nose or with the eyes, and when they come to the ears, the ears are here instead of there, and the cheeks are higher up. So, actually, they flatten out the face according to their feelings. When it's almost flat, they reduce the third dimension to their feelings to get the face. And then I go and take the face away, and say, "We want a *head,* not a face."

Brancusi made that beautiful egg-shaped head and he didn't put the face in. It was a head of *all faces,* which is much more than just this or that lady. There comes the human vanity. I am very sorry to say those portrait paintings, which are usually ordered to hang in lobbies of universities or firms must look as the person would appear in a photo. This isn't our purpose at all. The artist of today is somehow, through mechanical inventions, farther ahead than the artist of the past.

When Rembrandt painted his portraits, he put his feelings in. He could put his feelings so beautifully to the task that the person would also look like a particular person. That was the great mastery of the masters of the past. But their art was not great because the faces and figures looked like the people. Actually, Rembrandt lost his commission for "The Night Watch" because the figures didn't look like the people who were posing, or at least they thought not. Would anyone care what that Captain So-and-So looked like in the seventeenth century in Amsterdam, or care much more for the painting?

"The Night Watch" was actually a day watch, as we discovered after World War II. The painting was hidden in the salt mines, so the Germans couldn't get it. After the war, when it was brought out of the caves, all the varnish of the centuries was removed, and according to the light and shadows, it was about four o'clock in the afternoon. Through the centuries the varnish had darkened. People said, "It's dark, it's the night watch."

Coming back to the portrait, today we have photos, color

photos, likenesses, fingerprints, ear casts–I would think even texture prints of the skin. Why do we need a painter to paint someone as he is? What we really have to discover is the un- limited realm of the soul. If we don't have to bother anymore with how the nose looks, and the eyes and the lips, we can freely put all the energy into the search for the person's soul. Not only the soul, but the artist's soul searching that soul. It is most difficult, because I don't know my soul yet, nor do I know the subject's soul, nor does he know his own soul. Can you see how difficult that abstract portrait would be to approach? And then, most people who don't know anything about art, or don't care about art, come and say, "This is not good; it is crazy." In this, they make a statement involving psychiatry, which they know nothing about either. Who are they to tell us we're crazy? The public makes so many mis- takes.

What I hear said at exhibitions could fill books–books of ignorance and belligerence. If the public doesn't know, they defend their not knowing very vigorously. If they would use the energy they spend in opposing art to understanding it, they would do themselves a great favor, and the artists, too. They don't have to like it. It isn't a question of likes or dis- likes. Things exist whether we like them or not. The atom bomb exists, whether you like it or don't like it. It is here. You can't do a thing about it. We just deal with it and live with it, and try to understand it, and maybe by so doing re- move the fear and the danger. By attacking it, we will not find a solution–not in the case of the bomb or in art. Those in the past who found the truth somehow and were not un- derstood, generations later were understood.

We always find and rediscover forgotten artists. Why do we rediscover them? We find in them a new truth that was forgotten. We are so hungry for it that we even dig out mum- mies to find it. And when Western civilization was tired and worn out, and repeated like a seven-day-old soup, then we went to the Africans, to the primitives.

The great deed of Picasso was that he stripped himself of all the knowledge he had, and he was actually drowning. He moved his arms, symbolically speaking, and saved his life. Every real artist should learn as much as he can, study as much as he can, take in as much as he can. And then he should forget it, strip himself of all the knowledge he has and fight for the new life. This is creative art, and this is contemporary art. What you will grasp in your desperate search to save your life may be a straw. Sometimes, it might not seem worthwhile to the others who don't dare; but don't forget that Picasso saved his creative life. Whatever he did is not the question. The great deed of Picasso and of the other modern artists is the reason they were attacked.

I saw a Dubuffet show in New York and later in Chicago. (It was better hung here than in New York, and I was very proud of it.) There are such wonderful textures in his paintings. He actually discovers nature again. The surface of a stone, the surface of skin, they say, are abstract or do not exist. But skin covers us. The surface of a stone, the grass! There is much more of the truth in his paintings than in our egocentric observations of how we look.

There is a famous saying of Max Liebermann, the German Expressionist. He painted portraits, and he painted very strongly–really a step in the modern direction. Everybody wanted him to paint their portraits, but they weren't satisfied with what he painted. He was rude, and he always asked, "Do you want a portrait of how you would like to look or how you really look?" Then, they would answer, "I want it as I am." But when they saw how they were, they didn't like it.

I won the competition to make the sculpture for the Fire Academy on the site of the origin of the Chicago Fire of 1871. I was very honored to hear about it. It took us a very long time to remember the victims of the fire, which was the second greatest disaster in history, and I think it is to the

credit of the Chicago public and the city that they put up a monument.

I made all my preliminary sketches and compositions, and when I was through with them, then I studied every historical aspect of the Chicago fire. At first, I did not want to be influenced. As a human being with artistic feelings, I could feel what misery fire could cause. I could trace and retrace the emotions that a disaster of such greatness could bring without having the data. I read later about the reality, and it confirmed the first instinct I had about it.

They built a modern academy to educate firemen on the spot where the Chicago fire broke out. Mrs. O'Leary's cow supposedly started the fire. When the competition began, there were several who would have put Mrs. O'Leary's cow there. Thank God, that idea didn't win. Twenty years ago, it would have, I assure you. But fire isn't just a cow kicking over a lamp. Fire can be a curse, a blessing, and a curse again. I won the competition, I presume, because I was the only one who showed the fire in a more creative way. I showed not only the destruction, which it is, but also its blessings, from the warming, life-giving rays of the sun to the destructive lava of the volcano. Even the lava of the volcano, after centuries, is very fruitful. So there is not a total loss. In other words, the greatest catastrophe has something good, and the greatest blessing is something of a catastrophe, too. Nothing is perfect as long as we rule the earth, and we are supposed to rule the earth–that's why we are here.

Speaking of perfection, we do the best we can. That is good enough. It is said that Japanese artists, when they had a very good painting or print, would break a corner off of it so the gods wouldn't be jealous of the perfection. Man shouldn't be perfect. The artist did his best, and then just chipped a little off to prove that he was not perfect after all. Man's imperfection is his perfection!

In the first model for "The Pillar of Fire," I started with

movement. Fire always moves. With this I won the preliminary competition along with some others. From this model
I came to a simpler form with five flames. At first, no one
knew who was competing in the contest or who was on the
jury. The works were either accepted or rejected. The artist
had to write what he meant, as I explained. I meant the creativity of fire, the disaster, the sunrays, the warmth, the destruction, the symbol of the flame of the Holy Ghost–so
many things. You see, at the first Pentecost, the Holy Ghost
appeared in fiery tongues. Fire is prominent throughout the
history of mankind. The Vikings burned their dead in honor
of the glory of the sun. I have studied Scandinavian gods,
their Viking ships, and their wonderful wood carvings. I
wouldn't be surprised if that wonderful line I conceived for
the flames might subconsciously have come from the Viking
ships. Who knows what one learns subconsciously?

In Norway, after I won the final competition, I developed
two models from a sketch. First, I made a small-scale model
(one meter), then a larger one of ten meters, or thirty-three
feet. I worked directly in sections of plaster of Paris. I never
saw it all together–I couldn't. I had only one third of the
figure at a time to work on, and I had only one helper. My
helper was very dedicated to the cause and to me, and understood it.

We built the sculpture like the wing of an airplane, circling
the inside circumferences the way one would go up a spiral
staircase. Then we covered the framework with plaster of
Paris and developed the elegant swing of the composition. It
is impossible to copy a work like this from the model or measure it–I didn't even want to try. Measuring must be done
from the outside. Small forms look different when they are
big. They can't be blown up; they must become big in a continual state of becoming. The size or dimensions don't always
determine the dynamics or qualities of a work. But certain
works have a monumental birth, and others have a small
birth. "The Pillar of Fire" was a monumental work. I built

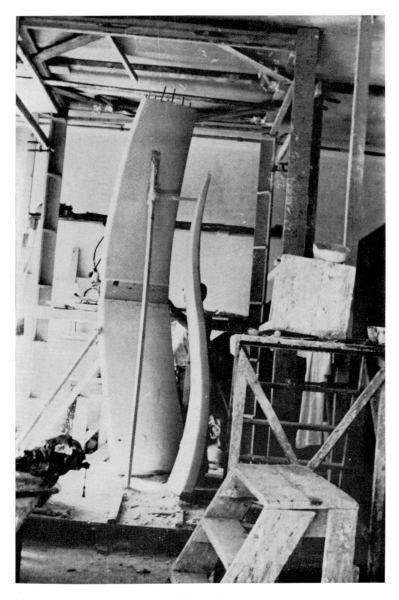

Figure 2

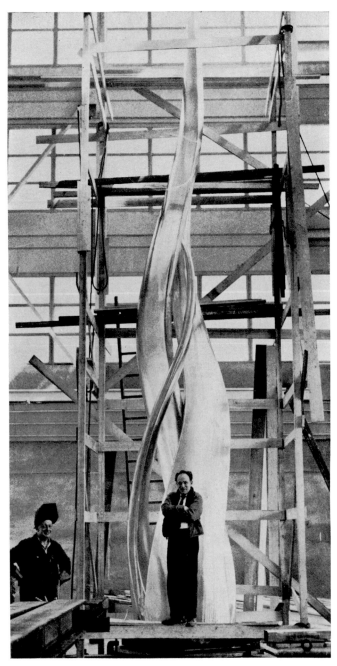

Figure 3. "Pillar of Fire" during work with scaffold.

it up like a tower. When it was cast in bronze it was cast in sections, and when we put the bronze sections together, we had to have a scaffold. We crawled around on that scaffold like mountain climbers. The making it in plaster took me a year, and then the casting in bronze took a year, too. When it was finished, we still could not remove the scaffold until the steel beams were put next to it to pack it and crate it. When it was finished, I still saw it only in the crate, which didn't show too much. Then it was shipped to the United States. I put it up, still in the steel crate, and we started to cut the beams slowly with the torch, with asbestos between the steel beams and the bronze, so as not to burn the bronze. When it was unveiled, I actually saw it the first time as a whole entity, as it really was. I was just as surprised as those who were there to see the unveiling. I had my visions about it, I had my conception of it, and it wasn't strange to see it. Still, between the dream and the reality there is always a difference until we see and experience that the dream has become reality. And this is one of the finest moments for an artist.

I worked two years on "The Pillar of Fire," and when it was erected, I was still on fire with nothing to burn. You know, that's the greatest tragedy, that one doesn't know what to do afterwards. The work is finished, but the artist still burns!

I think the feeling might be like that of a mother or father when the daughter or son gets married. All of a sudden, the artist or parent is so happy it's done, and then he sees that the great happiness is actually no happiness. With what does he live now? What does he have to fear, what does he have to worry about now? What does he have to fight and convince now? Nothing. He stands there, and out of this vacuum, he makes new works. Or he fights with his wife or his children, and it's no good. Nothing comes up. That's when some people become very disagreeable. It's understandable. So,

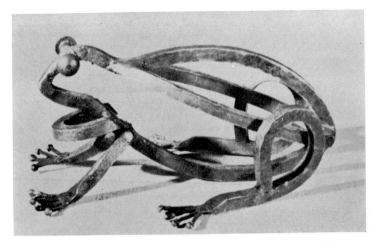

Figure 4. Egon Weiner's "Outer Frog" (forged iron, 1956).

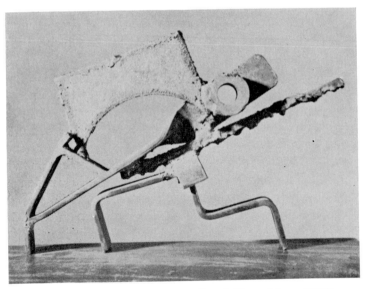

Figure 5. Egon Weiner's "Inner Frog" (forged iron, 1956).

now I can look at it as if it weren't mine. From somewhere else, there comes a commission, and it starts all over again.

I made a frog thirty years ago–I even glazed it green. Was I happy! It looked like a frog. I proved I could make a frog. But I don't have to prove that the body is there.

I have another one which I call the inner frog; it's abstract. And people say, "How did you arrive at this 'inner frog'?" I really don't know what I did, what it means. When it was finished, I was asked, "What is it?" So I looked at it, and said, "I made that frog first. This is the next work." From a certain view, it looks like a big eye. Maybe if I had never seen a frog, this would be my frog, as I would have constructed it in my mind. Maybe this is my inner frog. So I called the two "outer frog" and "inner frog." I always had them at exhibitions together, and this was always a question of interest.

Mr. Charles Stade is a fine church architect, who has won several prizes. I made a St. Paul for him, in Mount Prospect, Illinois. Then he called me last May and said, "I have restored and modernized a church, and I have fixed it up nicely. Over the door is a space for sculpture, and I think you should do it." And I looked at the church, and it was beautiful, really inspiring. He used the Gothic motif, but he didn't copy Gothic. He felt the building was already copied Gothic; so he kept the Gothic motif, but gave it a modern flavor. I used that modern Gothic flavor in my composition. At the time of this writing, it is in the making and will be fourteen feet high. It is made in plaster of Paris, and will be cast in bronze. Then it will go to La Grange. Now this is naturally big. As I made it bigger, I left out certain details which look interesting in the small model. I know of art committees which are made up of realistic men, and they give money for the church. They don't tell me anything anymore, because I know how to approach them. I tell them, "Here's the model; do you like it? The big one will not be like the model exactly. For instance, your little daughter is now five years old.

When she is twenty, she will not look exactly as she does now at five, but there will be a resemblance. And as we hope the bigger girl will be better than the smaller girl, so I hope the bigger work will be better than the smaller one. But if you handicap me, you will have a blown-up little girl who looks five years old and is twenty."

Some of the slides I took of my work, as photography, naturally can't be very good. But as evidence for myself that the moment took place, they have value. The time comes, and I just shoot, and sometimes I'm lucky. In excitement, a person's visual eye functions better than his thinking processes. It's like driving. We do it by reaction. If we have to think first what to do, it's bad driving, isn't it? One reacts by instinct according to the situation.

The section shown in one side of "The Pillar of Fire" is one-sixth. The scaffold was always around the work. We couldn't do without it. So I always had to look through it, to try to see the work without the scaffold.

The bronze parts were done first in plaster of Paris and then were cast in bronze, naturally three eights of an inch thick, but hollow. Still, it weighed seven tons alone, and with the crating it was fourteen tons.

So there are first sixths and second sixths. Then this was in the factory. Standing next to it, I can just reach one-sixth. When I was on the top, I crawled up and I felt a little sea-sick. The whole thing was shaking. But it was built like the Viking ships—one thinks it will fall apart, but it never does. It swings around.

In another slide, taken when the project was near completion, it seems so big one can't come close enough. And close up, it looks small.

The entire sculpture is only four feet in diameter. Within those four feet of space, it is enormous. The power of the curves seem to move it through space.

When the work was unveiled, a student of mine, the wife of actor Melvyn Douglas, said, "You know, Mr. Weiner,

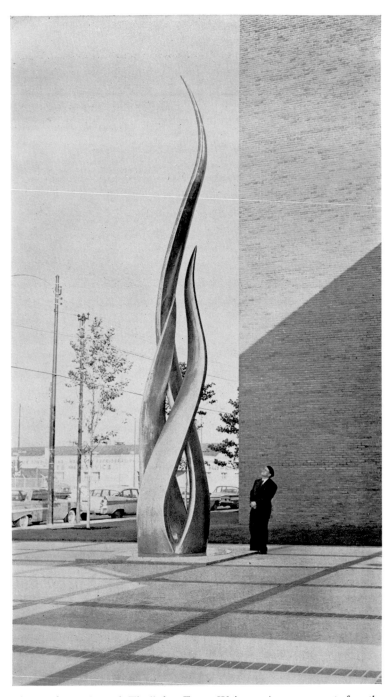

Figure 6. "Pillar of Fire" by Egon Weiner. A monument for the victims of the Chicago Fire, it won the American Institute of Architects Honor Award in 1962. Unveiled October 8, 1961, it is bronze, 33 feet high.

this looks like the forms of many beautiful women's legs."
I said, "It's nice you said it, because my whole life I
have taught sculpture and life drawing, and it must be that
those beautiful curves, even in the abstract, could come, and
probably do come, from female forms."

"The Pillar of Fire" hangs in the air, and the trick was to
get it down on the prepared spot. The engineer said, "You
can't do it," and I said, "I saw on television years ago that
they took those missiles and set them straight down and then
blasted them off into the sky." (See how important it is to see
other things than art) "And before the blast-off, the scaffold
fell away and the missile flew into the air." And I told him
we had just the opposite. We had to set the scaffold down in
a certain place with the crane. And so it was.

Sculpture Today

I N LOOKING AT NATURE, we see the pebbles and the stones that were washed by water for hundreds of thousands of years–these are the beautiful forms that the sculptor is actually so impressed by. The stone forms are more essential than our flesh, really. I'd rather see the beauty of a pebble and then refer to part of the body, than the other way around. It's so sensuous, because water caressed the stone for hundreds of thousands of years, making it beautiful. Flesh is too limited by time.

I remember that Henry Moore as a young artist studied at the British Museum, and that was one kind of information. The other kind of information he gathered on the beaches of the sea in England where he went to pick up the pebbles and learn the beauty of those stones. This is the greatness of his sculpture–that it is simple, and essential, and penetrating– it's the form of nature.

Modern architecture is built almost the way the bees would build their hives. The secret is that we have the technical equipment to see things that are very small and microscopic, or to see into the skies. We have much better tools now to penetrate nature. Naturally, we have to change by being impressed. But look at the beauty of a stone. How can we compete with natural beauty? We can't; we can only learn by it.

This is rhythmical in nature and horizontal geometrically.

It fits one's mood, and whatever name it has is only a title. In the same way, a human being gets a name, but that doesn't make the human being. It is just the surface–the love with which the artist treated the whole thing. It must be good. It might be; it doesn't have to be. But there's a sensuousness in natural forms–simple forms. It is almost as though they had their own sex hormones. There are people together– a man and a woman–togetherness is right there and it gives the sculpture and ourselves and life a deeper meaning.

One work by Brancusi looks like a nut from one angle, until it is turned around. And yet at the time he made it, it was so modern it looked almost like a neoclassic head and face. It's entitled "Miracle" because it is such a form, that rises from the horizontal into the vertical. It's rising, as we stand up on our two legs, and this is the million-year-old miracle when a child stands up.

The reflection of the material or of the world around the "Bird in Flight" by Brancusi is included in that shiny metal. That voluptuous form reveals the beauty and texture there. The excitement and the little nervousness as light touches the surface–this is an impressionistic adventure already. The light hits the surface of that bronze and we learn from the Impressionists how to honor it more, and so our forefathers gave us something to work with.

The old rocks could be from thousands of years ago or from today. Henry Moore with his concrete feeling–the positive-negative–has the same power and then penetrates into another distance. He goes through the metal and conquers the distance with it or what's behind it. And we know from Moore that he likes bones and skulls–and the essential forms of life are there, much more so than in flesh. I like those animated films going deeper and deeper, conquering with every hole a new world, a new vision–a new world of vision. It's beautiful! It makes a person feel bigger, penetrating into distance he didn't see before.

This is almost musical, isn't it? Henry Moore started early

with those string compositions. His style is divided: it is mu-sic–it is engineering–it is sound–it is vibration–it is all that–and it is esthetic, and organic. Things grow and it is hard to teach because everyone has his own growth, his own qualities or "disqualities," if I may use that word. And that's what makes a different artist. And how can another one do it if he has to do it. . . . Look how a work pulls together like lines–sometimes in drawing one piece of sculpture, there are hundreds of thousands of drawings or lines put together to form a three-dimensional piece. It's very rich. It's an enor-mous energy to conquer space–the third dimension is space –and with drilling a hole or getting through a piece of rock the artist conquers space, and we are very conscious of space today anyway.

The Calder mobile, an enormous invention, catches the weight, the static moment of sculpture; until Calder, every piece of sculpture was standing on the ground. With his mo-biles, one can see the sculpture from up, down, and through; they move in space.

The idea is interesting and almost primitive, almost savage. We are so modern that we can go back to the savages and learn from them the beginnings of feelings and become purer and simpler, and find more meaning; like the sundial, almost, the idea is to pray to the light, to the sun, to their gods–whatever they knew or didn't know. One can see interesting faces and expressions and coloring. This is a fellow you might meet on State Street–with a beautiful expression in his eyes–how they speak of the hidden inner qualities. Some faces show their inner qualities, and some hide their inner qualities. Some are extroverts and some are introverts in their expression.

The animal forms express power. Looking at something in the Art Institute, I always have a feeling that two human beings are meeting. It doesn't necessarily have to be man and woman, but it seems to be; and that coming together is an important moment because our generations depend on it.

One artist may be taken more by sensuous feelings and another one may be taken more by constructive things or compositions like this; it's all a great message of how manifold life is; its content can be seen and expressed, yet never enough. Generations will come and will show us things we never saw before, and if we are alive we can say, "Well, I saw it but I didn't know that it was so." And future artists will open people's eyes as the past artists have opened our eyes.

In Giacometti's works, the vibration gives us more the feeling of a human being than just the image of one. Or consider Marini's "Man on a Horse." The man is moving; it doesn't matter if he's proportioned. The movement, the motion, the man and the horse seem to belong together. Notice the enormous impact of the horse's soulful expression, or the less human expression of the man, more warlike, more belligerent, more aggressive. We show the beast in the man and we show the man in the beast, and both are justified. In the "Warrior," Moore took the impression of a Roman warrior and brought it to our times. We still are fighting wars as the Romans did.

The animation is coming. When the artist becomes very creative and lets his work grow as nature grows, then people ask him, "What is it?" It is not necessary to ask. It is creative–it grows and the artist feels it. Actually, I would say every work of art, whether one understands it or not, is art if one feels it is creative. It doesn't matter if one likes it or not. As in nature, there are animals we don't like; they still belong to nature. There are flowers and plants we are afraid of, but they still belong to nature. They grow, therefore they belong to it. The idea of previous generations that art should be only beautiful is a very limited one because their idea of beauty is so limited that time and their taste become very small. In understanding contemporary art, we at least widen the horizon to include more than just beauty. The excuse when a piece of art is not understood–when people say, "It is ugly, it isn't art, I don't like it"–is no excuse anymore,

and I'm glad it isn't. The artist lovingly grinds the stone to make the surface smoother.

I like it when the stone shows the strength of the material, when it isn't taken away through being handled so softly one thinks it's flesh. It always should look like stone. Even if it's polished, one should be aware it's stone. With metal, it's the same–even if we sometimes take objects and weld them together, we're always aware if the material is steel or iron or metal–we're always aware of the integrity of the material. Every material has its own integrity, and one shouldn't work against it. What one does in wood one shouldn't do in stone –what one does in stone, one shouldn't do in metal and so on. And in clay, the artist has a direct touch with the material–he has direct contact. Again, the artist uses his fingers and that's the beauty in clay modeling.

Interesting forms of metal or stone or bone can be welded together with iron or steel, and one gets a feeling about nature–one feels part of it instead of separated from it. Our studios become mountains and lakes, and fields and prairies instead of just studios with glass and a nice window. I think from here we are through. It is very inspiring, some of the rocks in the slides reminded me of the Easter Islands–they are beautiful. People should become interested in the Easter Island sculptures. We have to find out that we can't always go the American way and be given food on a silver plate. We have to learn too–finally the fellow who will see that will say, "What are the Easter Islands?" We should become a little ambitious–otherwise we spoil and grow soft in our flesh. We don't walk; we take the car.

The purpose here is to give people an appetite now for the cultural richness that surrounds us. We can give them the appetite, but they have to bite, eat, and digest. That is their doing and nobody can do that for them.

Afterthoughts

The artist is one who cannot live without art; as a human being he cannot live without love. All existing life is yearning for love, therefore let us observe the emotions which create art and the art which creates emotions.

* * *

It is said that a father who loves his son punishes him. It also could be that the son who loves his father punishes him.

* * *

There is no substitute for affection and love. It surpasses beyond and above our speculative willpower.

* * *

Are you disappointed with people who don't keep their promises? I am only disappointed when I don't keep my promises. When I fail, not when others fail, that's disappointing to me.

* * *

The important thing is to search, not to find. The finding is an unexpected reward. Be satisfied with the urge to search.

* * *

We have to learn to obey, by fear or love. By love it is creation; by fear it is obedience.

* * *

We are trustworthy when we are trusted and proud of being believed in; when distrusted, we get angry and feel hurt and as a revenge we prove the distrust–but be above it and believe in your self-trust in spite of everything else. It is better to be accused wrongly than rightly.

Man is the force of life; woman is the fulfillment of life.

* * *

Bring life into acting (actions) instead of acting (as on the stage) into life.

* * *

It is not easy to be a grown-up in a childish world and not easy to be a child (childlike) in a grown-up world. This is the condition and position the artist finds himself in.

* * *

The inner and outer necessity of the creative moment makes the artist inventive.

* * *

If we miss one or the other thing in life, we are sorry about it; but if we think we missed nothing, we would have missed something.

* * *

The artist must give more and be more than a reflection of his contemporaries' praise and understanding.

* * *

Most great artists are usually not recognized, until after their deaths; even then, they still aren't, for some people buy fakes. They buy the name and not the picture.

* * *

Truth and honesty are not intensified when brutally expressed.

* * *

Behavior has to be restrained according to good taste.

* * *

People have dreams and stay dreamers; the artist has dreams and works his dreams out.

* * *

A committee should give the artist a commission and then set him free and leave him to his inner reserve of creativity, which he cannot force.

Some artists (and students) are so defeated by defeat they cannot develop anymore.

* * *

The image of the King of Kings and all earthly kings and leaders should be on the prow of the ship of belief, freedom and dignity of man (Christ figure, American Norwegian Church, Oslo).

* * *

In unknown territory you don't know what is honest, the truth or a lie; you have to look and feel. Art has to be a necessity, not a seduction.

* * *

The artist is sometimes the visual consciousness of people –sometimes also the subconsciousness.

* * *

Grace has to come graciously (as in Greek statues), not by force.

* * *

Some artists are afraid of death, but most are giving, or must give, life.

* * *

If an artist does not say more than he knows, he does not say much.

* * *

It is better to be awkward and pure than slick and deceitful!